IMAGES
of America

LONG BEACH
FIRE DEPARTMENT

IMAGES
of America

LONG BEACH
FIRE DEPARTMENT

Glen Goodrich

Published by Arcadia Publishing
Charleston SC, Chicago IL, Portsmouth NH, San Francisco CA

Printed in Great Britain

Library of Congress Catalog Card Number: 2005926067

For all general information contact Arcadia Publishing at:
Telephone 843-853-2070
Fax 843-853-0044
E-mail sales@arcadiapublishing.com
For customer service and orders:
Toll-Free 1-888-313-2665

Visit us on the internet at http://www.arcadiapublishing.com

CONTENTS

ACKNOWLEDGMENTS

Herb Bramley is the reason the Long Beach Firefighter's Museum has the collection of photographs and documents used for this book. Herb had the foresight, willingness, and dedication to start a museum devoted to the Long Beach Fire Department, and then collect and store everything he could to preserve our history. From the beginning, our museum has had a staff of volunteers who are just as dedicated as Herb and take great pride in conserving our rich history. We have had tremendous cooperation from everyone, past and present, who works for our fire department, firefighter and non-firefighter. We must also thank every fire chief since the museum began, for their support and for recognizing the importance of maintaining history. Without their complete support, we would not have a place to store and show our collection.

All volunteers of the museum, through their determined efforts, have made some contribution to this book. A great deal of thanks must be given to coauthors Nicole Harbour, Mike Kenney, and Mary Alger for taking on the extra responsibility of going through hundreds of pictures and documents, and examining several scrapbooks to extract our history and a small sample of photographs for this book. Without their efforts as coauthors, this book would not have happened.

INTRODUCTION

The City of Long Beach, formerly known as Willmore City, first tried to organize a volunteer fire department on March 16, 1897, when a group of citizens saw the need after an increase in property fire loss. Twenty eight charter members signed up, with Brewster C. Kenyon as captain, John McPherson as first lieutenant, and William Craig as second lieutenant. The board of trustees appropriated the funds to purchase a hand-drawn ladder truck with equipment like leather buckets and axes. The ladder truck was housed in a building in an alley between Ocean Avenue and First Street. Several fund-raisers were held to purchase equipment like helmets, shirts, and belts for the members. In the spring of 1898, Brewster Kenyon resigned to accept a commission in the U. S. Army for the Spanish-American War. This led to the resignation of several other members and thus the breakup of the volunteer fire department.

The board of trustees met again May 27, 1902, and this time decided to form a more permanent fire department. J. F. Corbet was selected chief and H. D. Wilson selected as assistant chief, but due to business commitments both had to resign. Another reorganization took place and J. E. Shrewsbury was selected chief and N. C. Lollich selected as assistant chief. G. C. Craw was named foreman of Hose Company No. 1 with J. Robertson as his assistant. J. H. Morgan was named foreman of Hose Company No. 2 with E. J. Fisher as his assistant. E. O. Dorsett was the foreman of the hook and ladder with G. Gaylord as his assistant. All of the equipment was hand-drawn at this time.

The Long Beach Pavilion was destroyed in a fire on January 6, 1905, resulting in $15,000 in fire damage and three firemen were injured. Soon after this fire, a $30,000 bond was passed to build a permanent central fire station near Third Street and Pacific Avenue. Part of the bond was used to purchase a horse-drawn steam pumper, a hose wagon, a hook and ladder, seven horses, and alarm boxes. Chief Shrewsbury and Assistant Chief Craw moved into the new fire station in 1906 at 210 West Third Street, and the first alarm received by the newly installed alarm system was box no. 23 at the corner of Third Street and Olive Avenue.

Frank Craig loaned an automobile to the department to try out in 1907. With the test a complete success, the fire department purchased two Rambler chassis. Assistant Chief Craw oversaw the installation of a 35-gallon chemical tank with 200 feet of chemical hose and an additional 300 feet of cotton hose for each Rambler. Records indicate that the Long Beach Fire Department had the distinction of having the first motorized fire apparatus on the Pacific coast, beating Los Angeles by three months.

The transition to motorized equipment began in 1907 with the purchase of the two Ramblers. In 1910, the department bought a Mitchell Chemical Truck and in 1911, a Robinson pumper.

By the end of 1913, the Long Beach Fire Department would be completely motorized with the purchase of a Seagrave Hose Wagon to pull the Metropolitan Steamer, a motorized hose wagon, and the largest pumper of its time—a Gorham 1,100 g.p.m. pumper.

The department had three teams of horses—Major and Colonel pulled the ladder truck, Tom and Jerry (no kidding) pulled the steamer, and Prince and King pulled the hose wagon. The seventh horse was Barney, the smartest and most mischievous. Barney was the swing horse, who filled in for the others on their days off. He learned the different rules for pulling the ladder truck, the steamer, and the hose wagon, and could work with each team. But by the end of 1914, the department had sold all but one horse to the water department. Tom was kept to service the fire hydrants.

Chief Shrewsbury and Mr. C. Shaw, superintendent of the water department, were together in the chief's car when it collided with Assistant Chief Craw and his driver G. Wright responding to a false alarm on May 2, 1916. Chief Shrewsbury was killed instantly, making his the first death in the line of duty for the Long Beach Fire Department. Assistant Chief Craw was appointed chief after he recovered from his injuries. Captain Taylor, who was acting chief, was appointed assistant chief.

In the beginning, Long Beach was a small vacation town by the ocean with an 1890 population of 550. As the city grew, so did the fire department. Tourism was the main industry, but that changed on June 23, 1921, with the discovery of oil on Signal Hill. This caused a huge growth in population and the rapid development of wooden oil derricks. The lack of regard for fire safety by the oil operators led to a series of fires that kept the department busy for years. One particular fire lasted for 3 days, and involved 11 oil derricks and 3 "gassers."

Today the city of Long Beach covers an area of approximately 52 square miles and has a population of about 461,522 (according to the 2000 federal census). The census also states that Long Beach is the most ethnically diverse city in the United States. Long Beach has the second busiest port in the nation and an active oil industry, although the oil derricks have disappeared. All of these present many challenges for the Long Beach Fire Department. The department has come a long way from the days when volunteer firefighters ran to fires, and will continue to grow to meet the needs of the citizens of the city of Long Beach.

One

THE EARLY YEARS
1897–1933

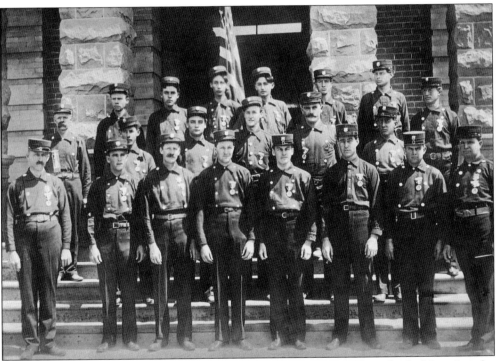

The board of trustees called for a citizens meeting on May 27, 1902, and asked Los Angeles fire commissioner Jacob Kuhrts to speak on the necessity of an organized and well-trained fire department. J. F. Corbert was elected chief and H. D. Wilson assistant chief, but both had to resign due to business commitments. The fire department was again reorganized. The new chief was J. E. Shrewsbury, and N. C. Lollich became the assistant chief. G. C. Craw was elected as foreman of Hose Company No. 1, J. H. Morgan as foreman of Hose Company No. 2, and E. O. Dorsett as foreman of the Hook and Ladder. Chief J. E. Shrewsbury is standing on the left of the bottom row and G. C. Craw is on the right of the bottom row. The rest are unknown.

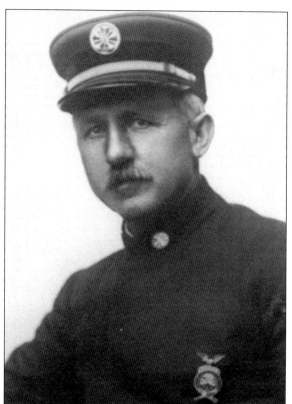

Chief Joseph E. Shrewsbury was elected chief in 1902, and remained in that position until his untimely death in 1916. The chief died in an automoblie accident while responding to a false alarm.

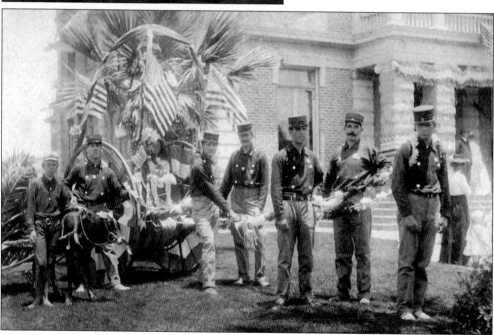

Hose Company No. 1 was placed behind city hall. In this photograph, city hall is in the background and the Hose Company No. 1 is decorated for the Fourth of July celebration. The people are unidentified.

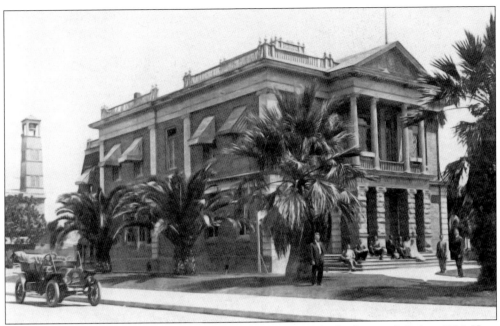

Seen here is city hall about 1909, with the fire alarm bell in the background. Before 1906, Hose Company No. 1 was stored behind city hall.

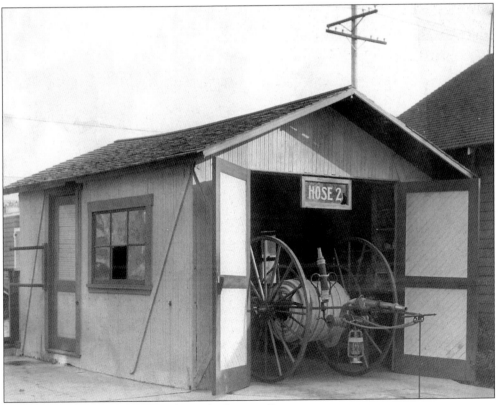

Hose Company No. 2 was housed in a shed in an alley.

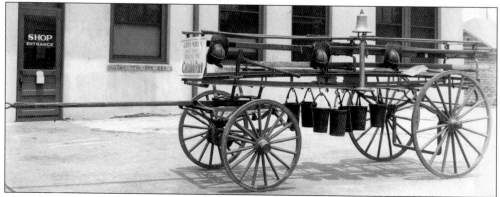

There is a story that when the ladder crew was running to a fire they caught up with a trolley. They hopped on board the trolley and towed the ladder behind. When they got to the fire, the citizens riding the trolley helped put out the fire. This happened between 1902, when the department purchased the hand-drawn ladder, and 1906, when the horse-drawn ladder was purchased.

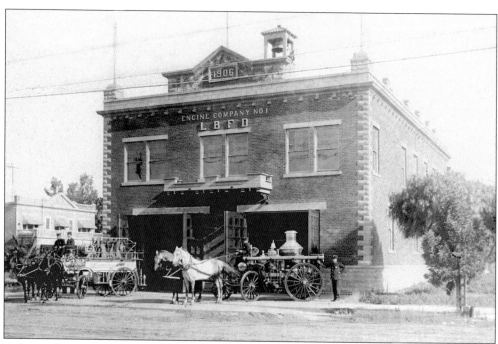

A fire at the Long Beach Pavilion prompted a $30,000 bond to be passed for the building of a central fire station, pictured here about 1906, and the purchase of fire alarm boxes, a steam engine, a hose wagon, a hook and ladder, and seven horses.

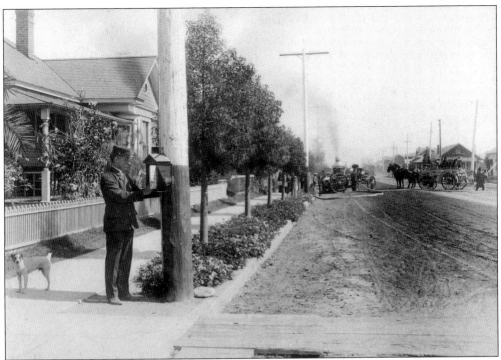

Chief Shrewsbury is shown resetting an alarm box with the hose wagon and the steam engine in the background. The first alarm box pulled in the newly installed alarm system was box no. 23.

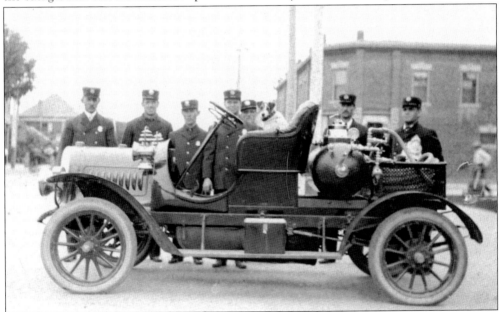

In 1907, the LBFD borrowed a Rambler from Frank Craig for testing and soon after purchased two Rambler chassis. Assistant Chief Craw was in charge of fitting both with chemical tanks and hoses. The department also had the distinction of being the first fire department on the West Coast to operate motorized fire equipment—beating Los Angeles by three months. In this picture, Chief Shrewsbury is standing to the far left and Assistant Chief Craw is fourth from the left.

S A L A R I E S

J. E. Shrewsbury, Salary as Chief Engineer, for October, ... $150.00

G. C. Craw, Salary as Assist. Chief Engineer $125.00
 " " " Salary as Fire Alarm Attendant 15.00 1.. 140.00

J. B. Taylor, Salary for October as Captain. 115.00

W. B. Cooper, Salary for October as Engineer. 105.00

C. A. Williams, Salary for October as Asst. Engineer. 100.00

G. E. Hocking, Salary for October as Fireman 95.00

Harry Lucas, Salary for October as Auto Driver,........... 85.00

W. S. Minter, Salary for October as Auto Driver,........... 95.00

Wm. Halterman, Salary for October as Fireman,.............. 80.00

J. W. Thrash, Salary for October as Fireman................. 95.00

Gee Wright. Salary for October as Fireman................. 75.00

L. V. Bruffett, Salary for October as Fireman................. 75.00

Joe Johnston, Salary for October as Emergency Auto Driver.. 75.00

J. M. Foster, Salary for October as Fireman................. 75.00

H. B. Ickert,, Salary for October as Emergency Auto Driver.. 75.00

J. R. Richardson, Salary for October as Emergency Operator..... 85.00

Arthur Peterson. Salary for October as Emergency Operator..... 75.00

C. M. Krieder, Salary for October as Auto Driver, 95.00

L. G. Bodine, Salary for October as Emergency Auto Driver.. 75.00

Orin Ingle, Salary for October as Fireman 75.00

G. M. Jewell, Salary for October, as Auto Driver........... 95.00

P. M. Lutting, Salary for October as Fireman................. 85.00

J. S. Penter, Salary for October as Fireman................. 75.00

D. L. Robinson, Salary for October, ass Fireman............... 90.00

J. R. Buchanan, Salary for October, as Fireman............... 95.00

F. S. Pearson, Salary for October as Auto Driver............ 95.00

Gee N. Combs. Salary for October, as Emergency Fireman..... 75.00

G. M. Palmer, Salary for October as Auto Driver,........... 95.00

This is a c. 1909 list of firemen and their salaries.

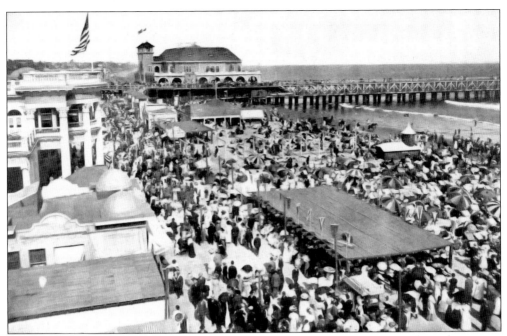

This is the Long Beach Pier and boardwalk in 1909. Tourism was the main industry at this time, and the population was about 23,000.

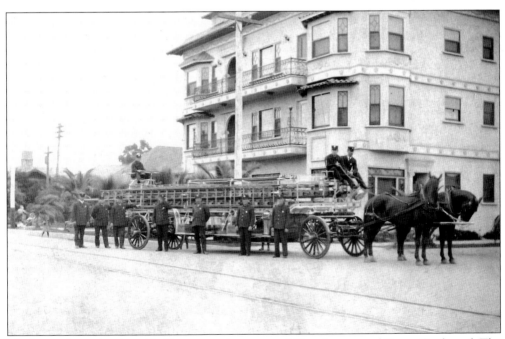

The horse-drawn hook and ladder is near the corner of Pine Avenue and Ocean Boulevard. The fire department operated three teams of horses and a seventh horse as a spare to fill in when one of the others had a day off. The names of the horses where Tom and Jerry, who pulled the Metropolitan steam engine; King and Prince, who pulled the hose wagon; and Major and Colonel, who pulled the ladder truck. Barney was the seventh horse.

FIRE MAINTENANCE FUND.

Receipts.

Cash on hand July 1, 1908.........................	$	698.73
Apportioned from revenue........................		18,974.10
	$	19,672.83

Disbursements.

Salary of Fire Chief..........................$	1,320.00	
Salary of other employees fire department......	8,821.86	
Attending fires and drills......................	776.00	
Horse feed	808.45	
Blacksmithing and shoeing.....................	160.45	
Repair of apparatus............................	116.18	
Electricity for charging fire-alarm system......	43.68	
Repairs of buildings...........................	41.50	
Office supplies fire department.................	17.85	
Furniture and fixtures..........................	37.55	
Repair fire-alarm system.......................	12.35	
Coal for engine...............................	2.35	
Coal oil, waste, soap, polish, sponges, etc.......	117.84	
Gas for heating engine........................	129.50	
Telephone	99.75	
Repairs and gasoline for automobiles...........	189.91	
Miscellaneous	304.21	
Tools for machine shop........................	10.22	
Water ..	1.25	
Harness repairs	10.00	
Fire hydrants	1,740.38	
New fire house First Ward.....................	1,445.15	
Equipment for fire houses......................	167.65	
Rent on lot for fire house.....................	25.00	
Supplies West Long Beach.....................	7.52	
Miscellaneous expenses of general fund........	1,148.93	$ 17,555.53
Balance on hand July 1, 1909.............		$ 2,117.30

This is the fire fund tally from the 1909 city audit report, showing fire department expenses for that year.

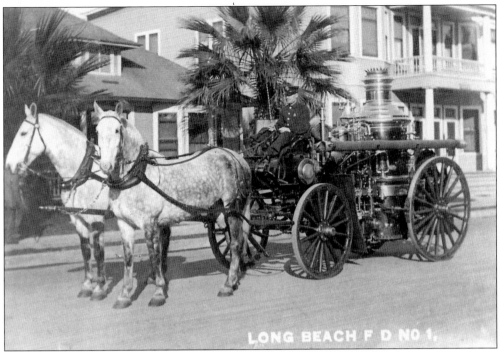

The Metropolitan steam-pumper is pulled by the horse team Tom and Jerry. The driver is unidentified.

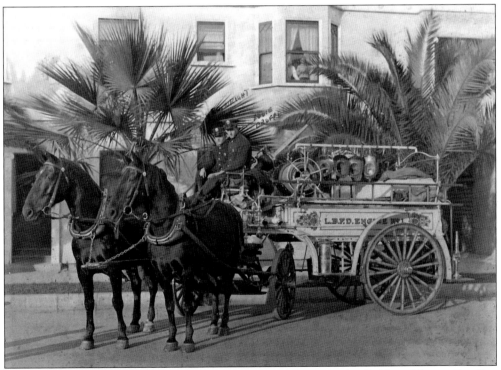

The hose wagon, led by King and Prince, pulls George Wright (left) and Louie Bruffet.

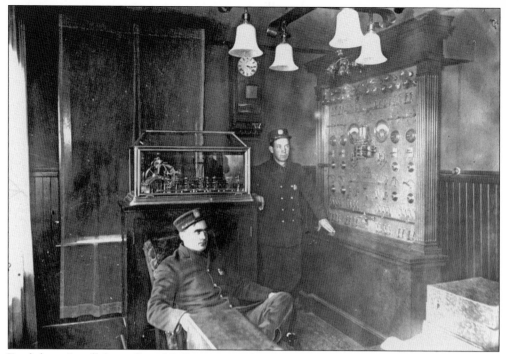

Firefighters Jewell (seated) and Folkner are in the alarm center. The alarm center building was added to the side of the central fire station.

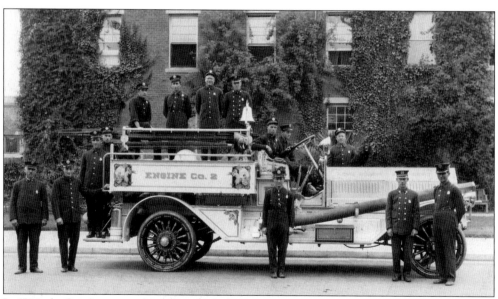

In 1911, the fire department purchased a Robinson motorized pumper and a Seagrave air-cooled tractor to pull the hook and ladder—marking the end for the horse teams. Pictured here is a 1913 Gorham pumper with Chief Shrewsbury standing to the left and Station No. 1 in the background. The rest of the firefighters are unidentified.

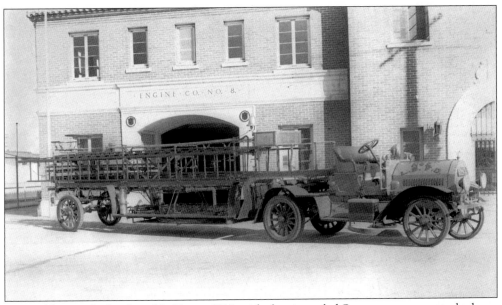

Pictured here is the hook and ladder, c. 1911, with the air-cooled Seagrave tractor attached.

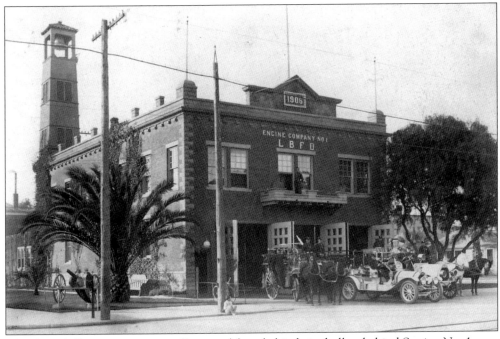

The alarm bell tower was eventually moved from behind city hall to behind Station No. 1.

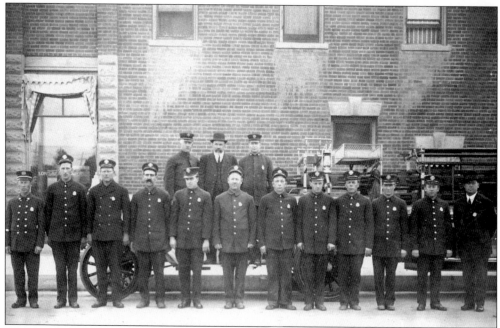

Chief J. Shrewsbury and Assistant Chief Craw stand with an unidentified Station No. 1 hook and ladder crew.

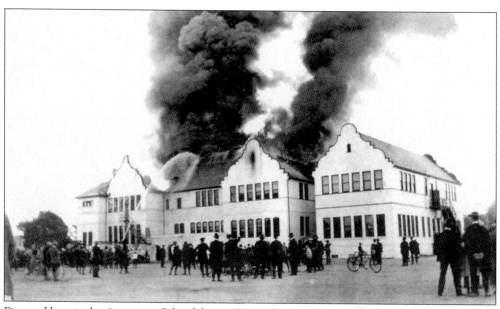

Pictured here is the American School fire on December 27, 1911, the first school in Long Beach. The school district still has a school at this location—Renaissance High School.

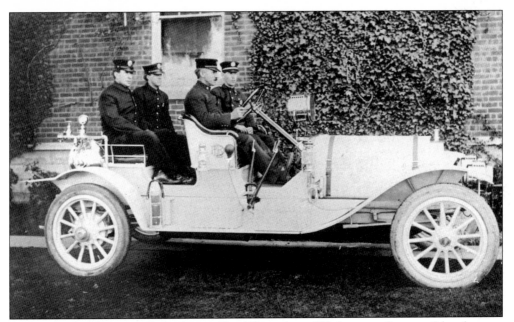

At the wheel of the Mitchell chief car is Chief Shrewsbury. While responding to a false alarm on May 2, 1916, the chief received fatal injuries in an automobile accident at Broadway and American Avenues. Assistant Chief Craw was also involved in the accident.

This picture shows the damage to the car that Chief Shrewsbury and his passenger, Mr. C. Shaw, the superintendent of the Water Department, were riding in. Mr. Shaw recovered from his injuries.

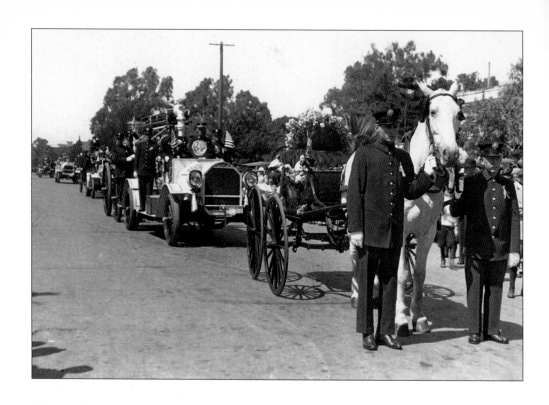

The funeral parade for Chief Shrewsbury was well attended.

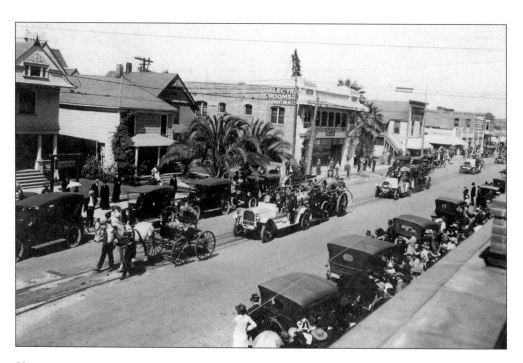

Chief Shrewsbury was respected by many and received flowers from around California.

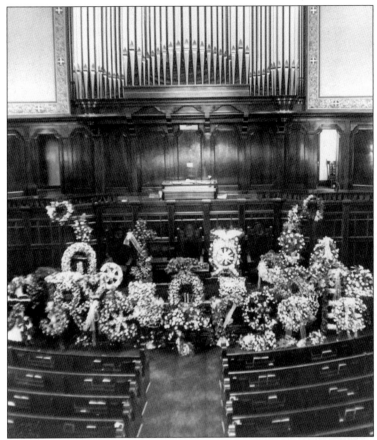

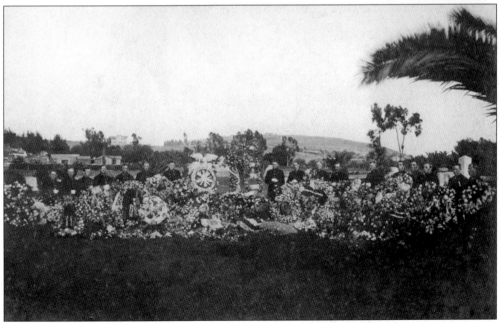

Unidentified firefighters pay their respects at the grave of Chief Shrewsbury.

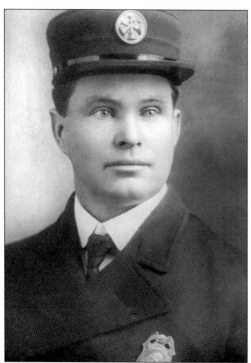

Assistant Chief Craw was injured along with his driver G. Wright in the accident. Capt. J. Taylor was appointed acting fire chief until Craw returned to duty—at which time he was appointed fire chief. Captain Taylor was then appointed assistant chief.

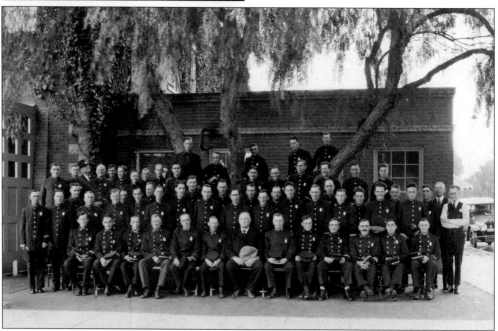

By the end of the 1917 fiscal year, there were 36 members in the fire department's four fire stations answering 128 alarms with a total fire loss of $27,192.99. The largest single fire loss occurred at the National Potash Company. The population of the city at this time was about 44,865. In this 1917 picture taken in front of Station No. 1, Chief G. Craw is sitting to the right of the civilian in the center of the bottom row and Assistant Chief Taylor is sitting to the left. The rest are unidentified.

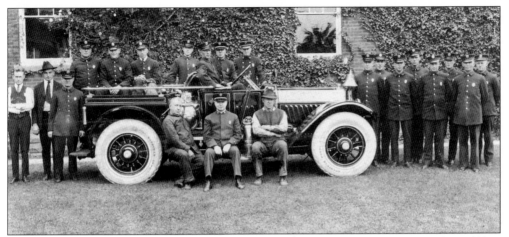

Seen here about 1920 is the crew of Engine No. 1 and Squad No. 1. From left to right are (first row, seated on the running board) M. Cooper, Chief Craw, and alarm superintendent Clark; (second row) Ray Peterson, Captain Rieder, G. Hocking, Jack Thompson, Victor Herbert, Fred Peth, Stanley Ellis, Ted Alstott, Bill Minter, Capt. Harry Lucas, Bill Simms, Tiny Henning, Loyde Kinnman, Forney Milton, Bill West, Jim Moran, Joe Johnston, and Glenn Croy.

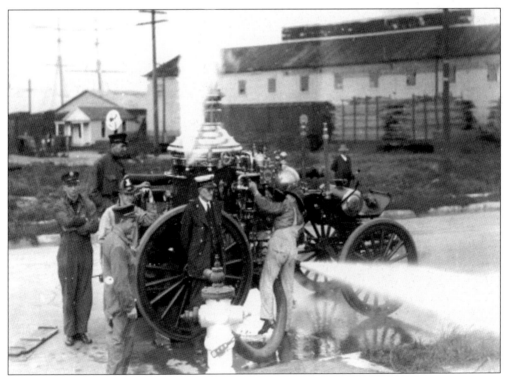

During the 1920s, a crew tests the steam pumper.

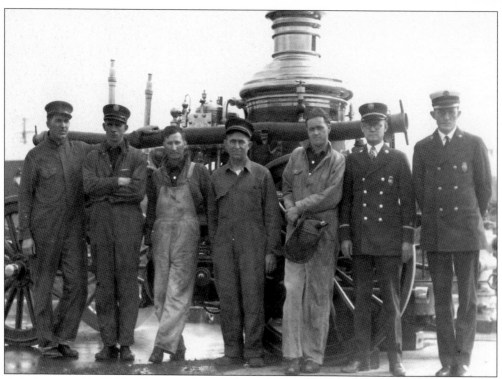

A steamer crew, c. 1920, takes a much-needed break from training.

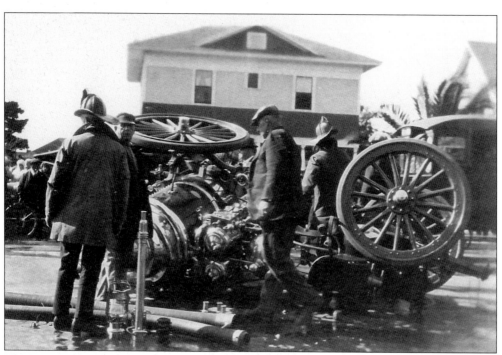

The Metropolitan steam pumper was heavy and had a high center of gravity. This 1920s wreck was probably the result of taking a corner too fast.

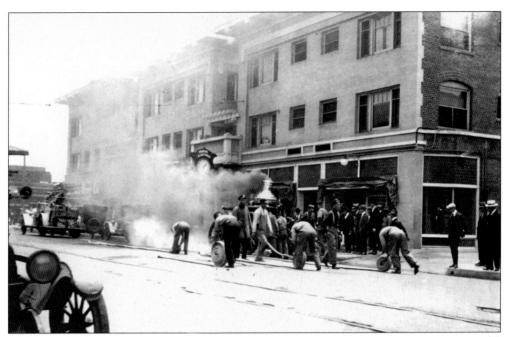

In 1913, a Seagrave hose wagon was purchased to pull the Metropolitan steam engine. In the foreground, firefighters pick up hose near the steam engine, and in the background (on the left) is the rear of the Seagrave Hose Wagon.

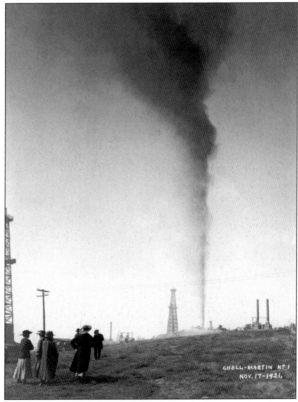

Up until 1921, the major industries in the Long Beach area were tourism and the film studios known as Balboa Studios. Balboa Studios started in 1913, and by 1917 was the city's largest employer and major tourist attraction. In 1921, that all changed with the discovery of oil in the Long Beach and Signal Hill area. With the rapid growth of the oil industry and the lack of safety, it was not long before the department was fighting oil field fires. Seen here is a gusher at Shell Martin No. 1, c. 1921.

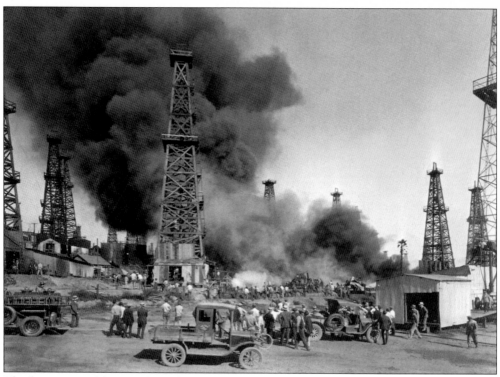

The first major oil fire was the Fisher oil fire in 1924.

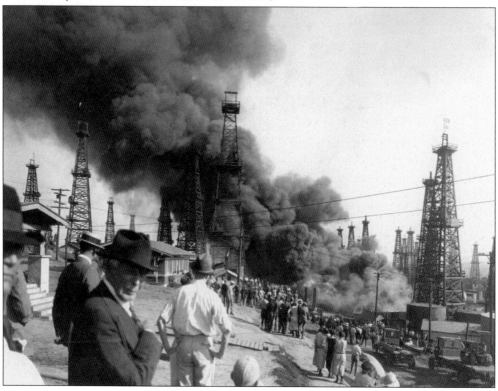

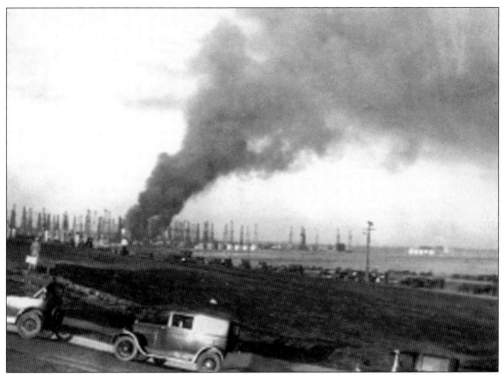

On June 26, 1927, the next major oil fire occurred—the Alamitos blaze.

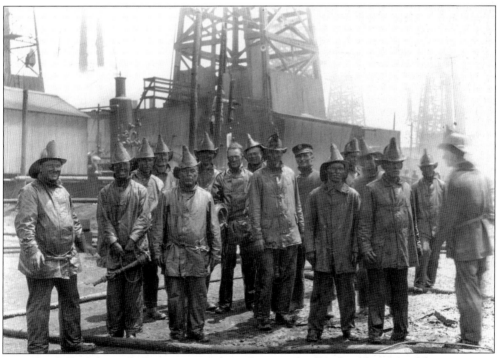

Long Beach firefighters find time to pose for a photograph after the Alamitos oil fire.

William Minter was appointed fire chief on March 1, 1926, after Chief Craw retired. Chief Craw was the first fireman to retire with a pension.

Signal Hill came to be known as "Porcupine Hill" because the sight of all the oil derricks in the distance looked like porcupine quills.

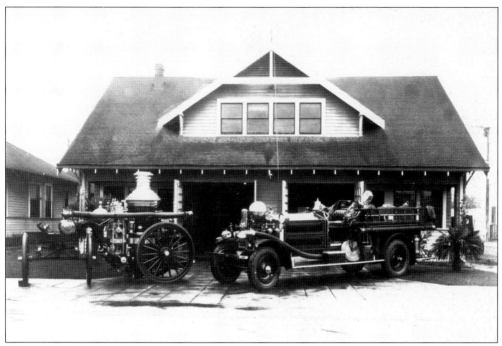

Station No. 2 and Station No. 3 were similar in design, and in the early 1920s, for some unknown reason, the station numbers were switched: No. 2 became No. 3 and No. 3 became No. 2. This picture is the switched Station No. 3 with the Metropolitan steam engine and a 1922 Ahrens-Fox in the driveway.

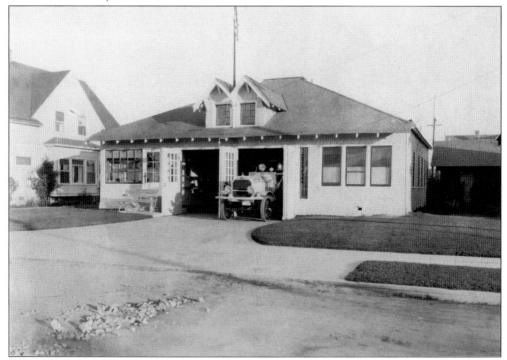

This is what would become Station No. 2, with the Gorham pumper in the apparatus bay.

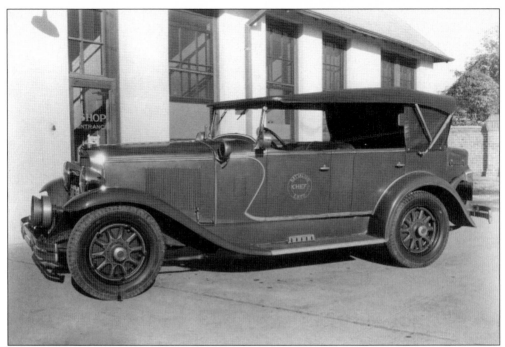

Pictured here is the battalion chief's car, a Graham-Paige touring car. The fire chief drove a Cadillac.

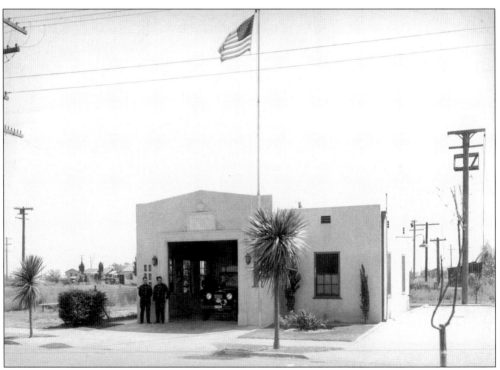

In the northern part of the city there was a small station, Chemical No. 3, at 2926 East Sixty-fifth Street. It later became a small grocery store.

CITY OF LONG BEACH

LONG BEACH. CALIFORNIA

April 1, 1930.

Gomer M. Wilhite,
Harold E. Maas,
Harmon B. Gearhart,
Long Beach, Calif.

Dear Sir:

Please be advised that I hereby appoint you to the position of Fireman in the Fire Department of the City of Long Beach, at a salary of $170.00 per month, effective April 1, 1930.

Very truly yours,

G. L. BUCK, CITY MANAGER.

On April 1, 1930, Gomer M. Wilhite, Harold E. Maas, and Harmon B. Gearhart received their notice of appointment as firefighters, with a starting pay of $170 a month.

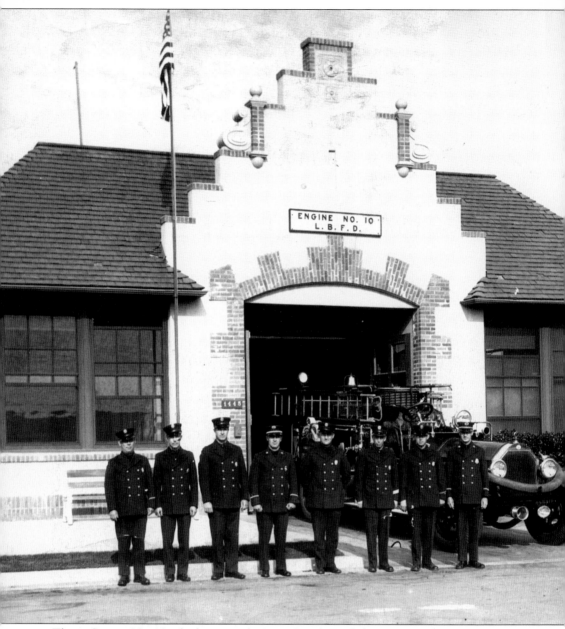

This is Station No. 10, which is now the Long Beach Firefighters Museum.

Two

Earthquake
1933

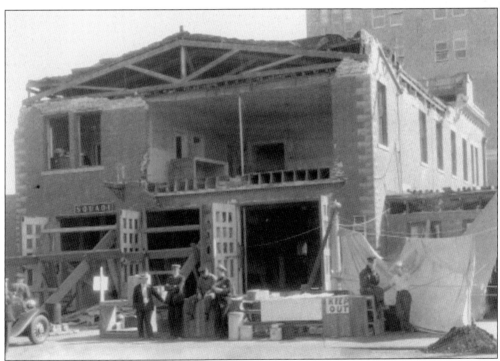

On March 10, 1933, a devastating 6.5-magnitude earthquake struck Long Beach, destroying many buildings including several fire stations. Firefighter P. T. Forker was upstairs in the dormitory. He had just made his way out the window onto the small balcony in the front when the face of the building crashed down on him. Lt. A. Stephens was downstairs in the apparatus bay when the station started to collapse. Stephens ran for the front door but as he reached the outside the wall fell on him. Both firefighter Forker and Lieutenant Stephens died at the hospital.

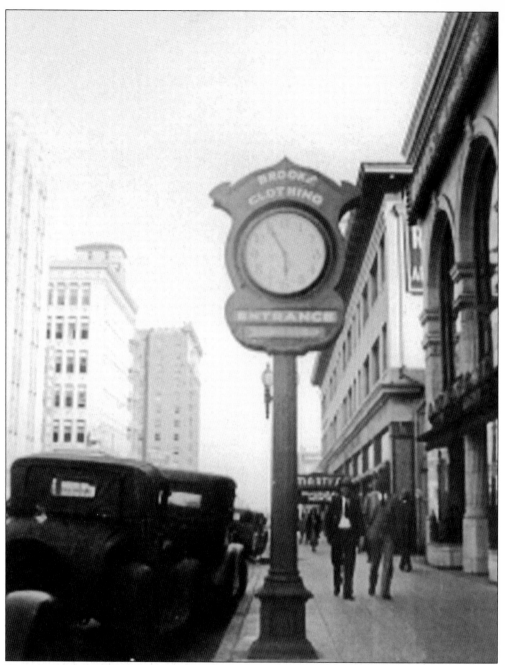

This clock stopped at the exact time of the earthquake—5:55 p.m. Many of the fire stations had debris in front of the apparatus bay, so the trucks had to be dug out. To complicate matters, there were four major fires at the same time.

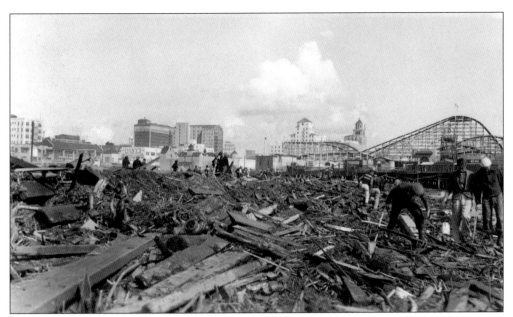

The Pike amusement area near the Cyclone Racer roller coaster experienced severe damage.

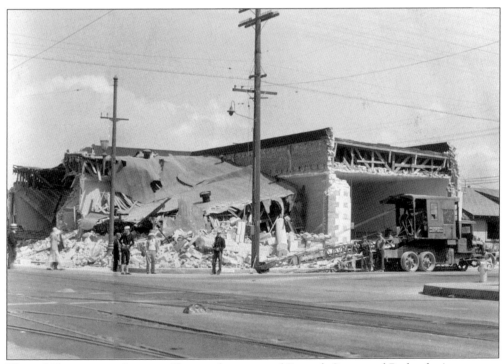

This rubble was once the post office on the corner of Seventh Street and Redondo Avenue.

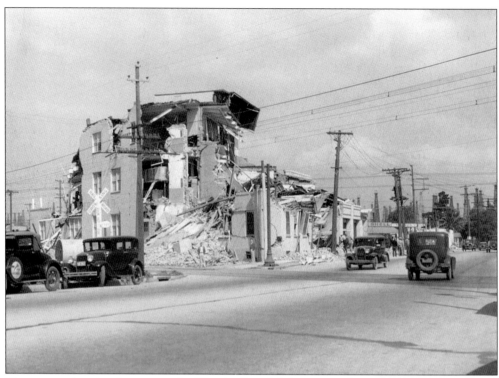

There was extensive damage to the Wonder Bread Bakery near the corner of Anaheim Road and Redondo Avenue.

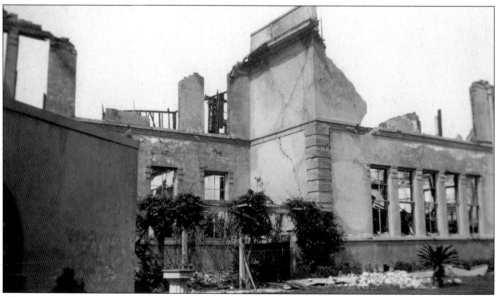

The science building at Poly High School was severely damaged.

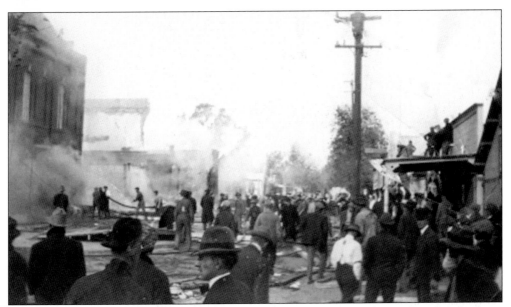

The citizens of Long Beach pulled together to help one another after the earthquake.

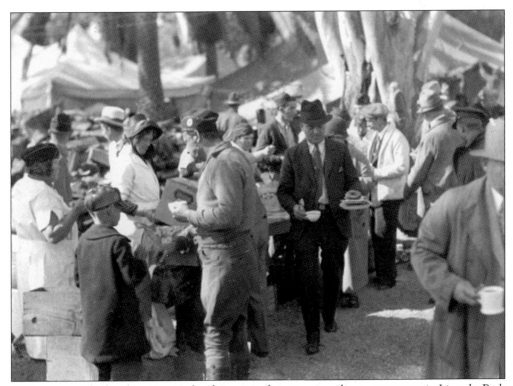

With many of the local services and utilities out of service, soup lines were set up in Lincoln Park to feed the thousands who were without food.

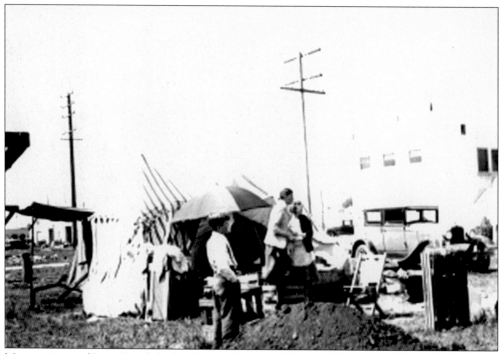

Many citizens of Long Beach had to live in tents until they could get their lives back together.

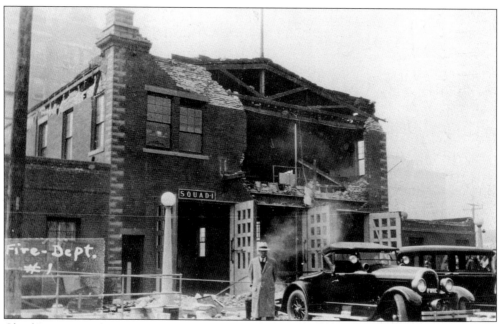

Chief Minter stands in front of the damaged Station No. 1. The alarm center was in a one-story brick building attached to the station and it too suffered severe damage. The electrical power and the battery backup were out of service, and there was only contact with 2 of the 12 fire stations.

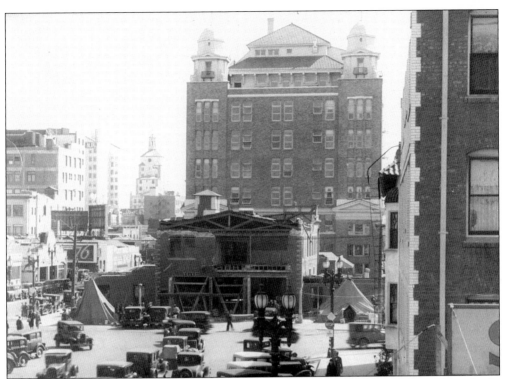

A large tent was acquired from the Barnum Circus to be used until the station could be rebuilt. City hall is in the background.

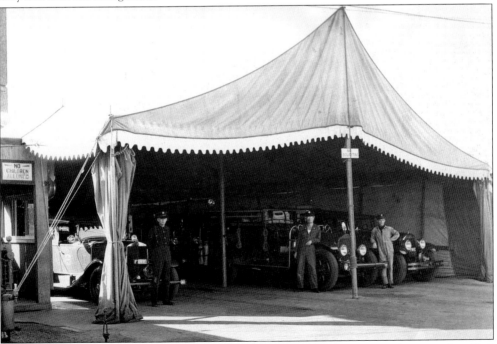

Here is a close-up view of the Station No. 1 tent with apparatus and an unidentified crew inside.

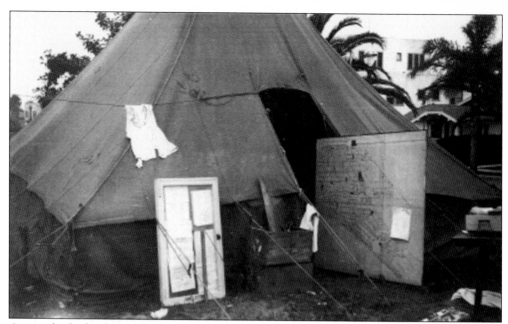

A tent also had to be used to house the fire department's headquarters.

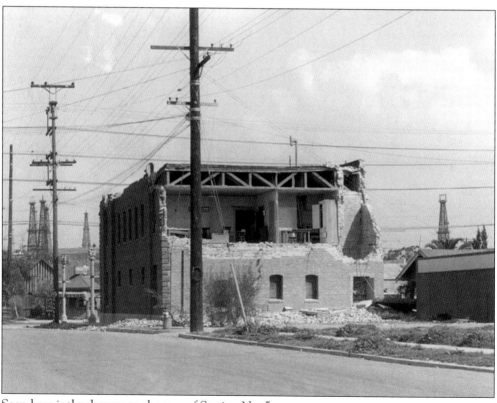

Seen here is the damage to the rear of Station No. 5.

This photograph shows what Station No. 7 looked like before the earthquake.

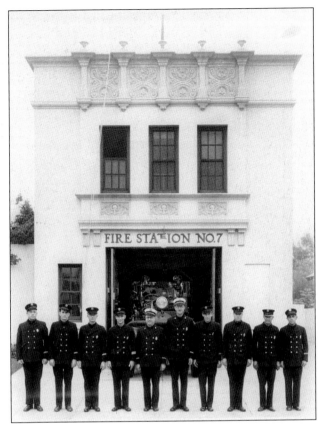

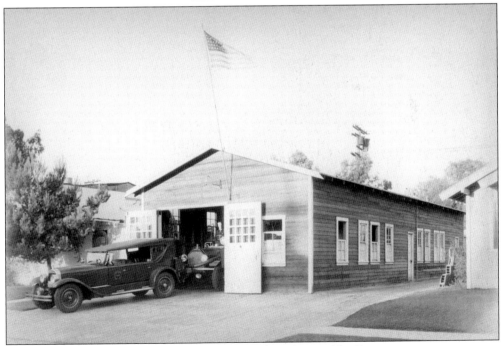

From 1933 to 1940, this building served temporarily as Station No. 7.

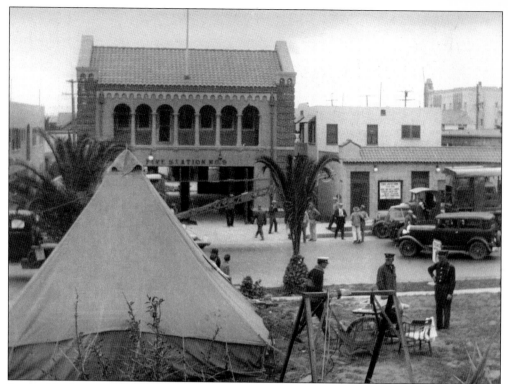

Station No. 1 was not the only station that was temporarily housed in a tent until a more permanent building could be built. Station No. 9 also used a tent as living quarters.

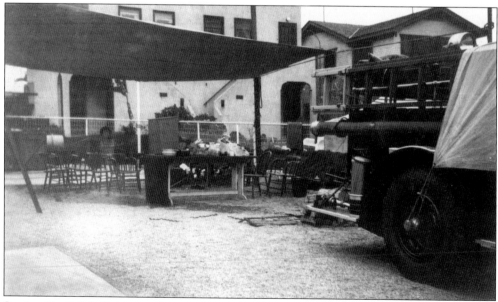

Station No. 9 did all their cooking in the outdoor kitchen.

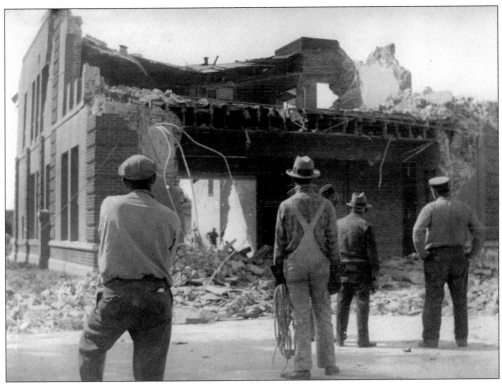

Demolition started on all unsafe structures including Station No. 9.

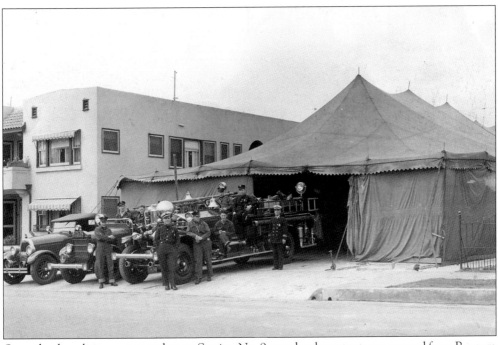

Once the demolition was complete to Station No. 9, another large tent was secured from Barnum Circus and placed on the same lot.

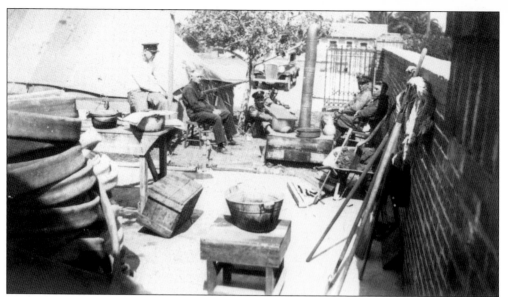

Station No. 10 also suffered some damage to the living quarters, and the firefighters had to live in a tent.

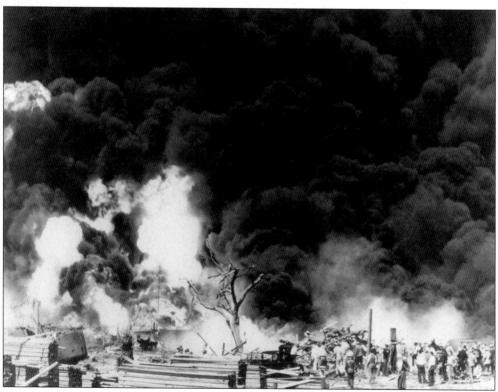

In June of 1933, there was an explosion and fire at the Richfield Oil Refinery. The cause of the fire was likely due to lingering effects of the earthquake in March.

The tree pictured here shows the force of the explosion at the Richfield Oil Refinery.

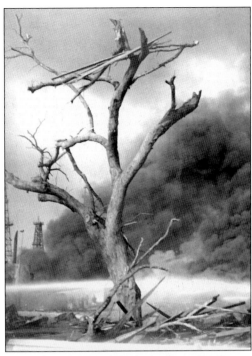

It was a tremendous effort by many to extinguish this fire.

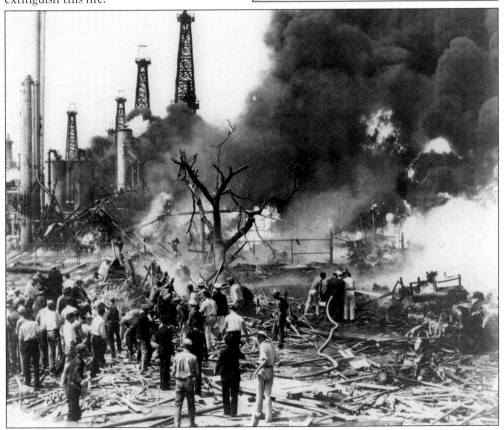

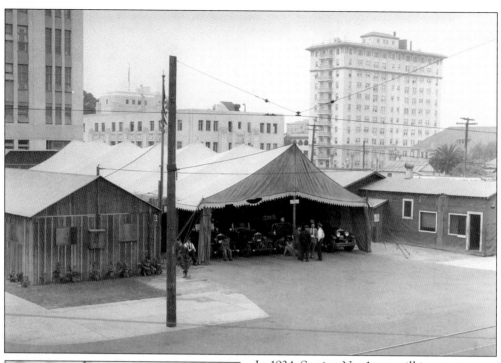

In 1934, Station No. 1 was still in a tent and city hall, in the upper left corner of the picture, had been rebuilt.

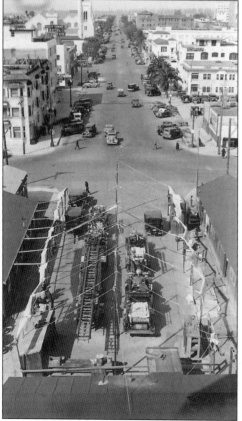

The earthquake was not the last disaster that happened to Station No. 1. Later in 1934, a strong wind destroyed the tent.

Three

THE GROWTH YEARS
1934–1970

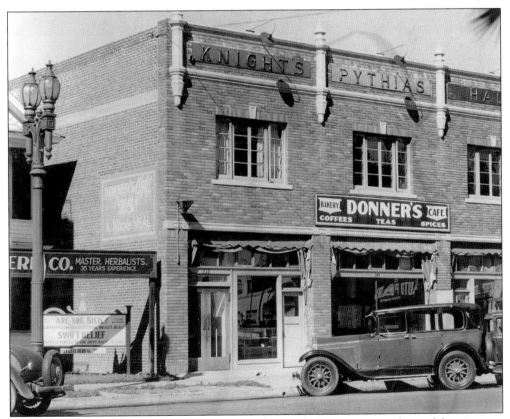

Instead of building a completely new station, the city decided to purchase and remodel an existing building for Station No. 1. The Donner Cafe became the ideal choice for a more permanent Station No. 1.

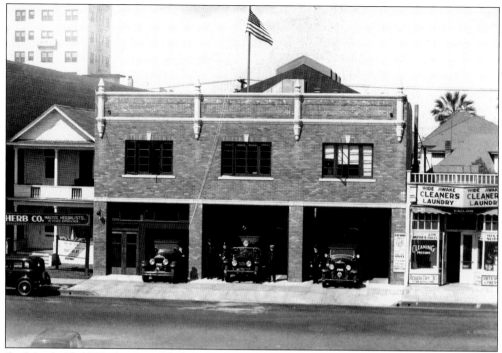

On March 16, 1935, the remodeled Station No. 1 was ready to move into.

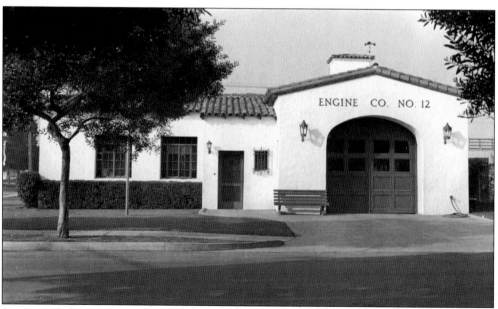

Station No. 12 was built in 1929, but due to the Great Depression and budget problems, the equipment and the manpower weren't moved in until July 1, 1936. Station No. 12 has remained unchanged since it was built, only some interior upgrades have been needed.

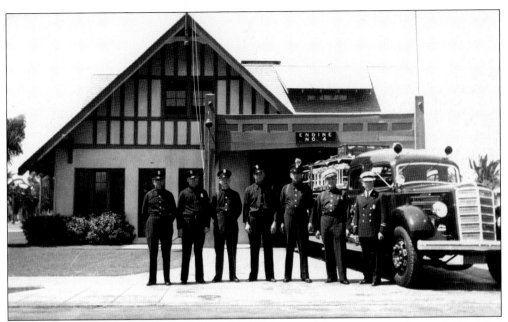

In 1910, Station No. 4 first opened at 411 Loma Avenue. This picture was taken in 1939 with a Mack 750 gallons-per-minute quad and an unidentified crew.

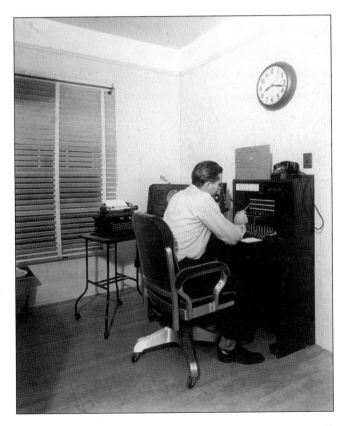

In 1939, "Talk Alarm" radio receivers were installed in all 14 fire stations. Here, Harmon B. Gearhart receives a call and is ready to dispatch the appropriate units.

Pictured here in the 1940s is the alarm desk with the Gamewell. The Gamewell is a ticker-tape device that punches holes in a narrow paper tape. The holes are a code that correspond to the number of a street alarm pull box. After reading the number, the dispatcher could then dispatch the equipment to a specific "pull box" location.

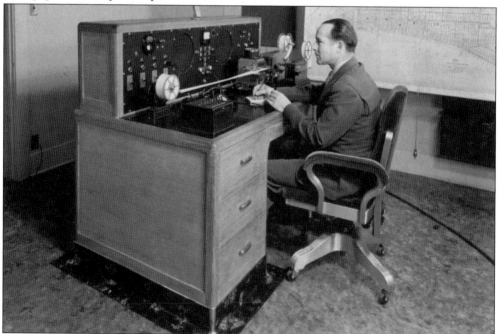

Harry Clayton is seen here in the 1940s manning the alarm desk.

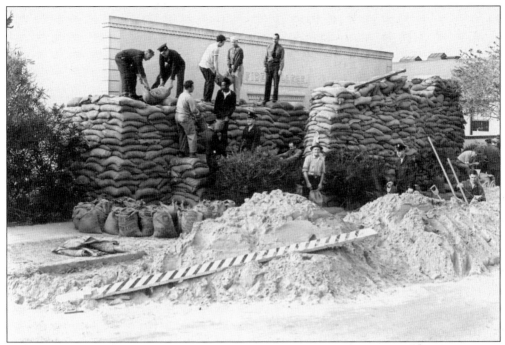

Just after World War II broke out, the building that housed the Fire College and the alarm center was protected with sand bags.

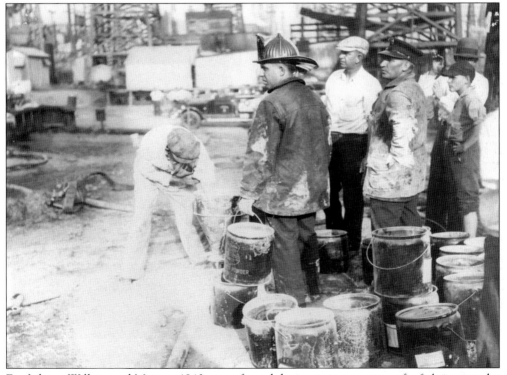

Firefighters Wilhite and Muis, *c.* 1940, use a funnel device to incorporate a firefighting powder into a hose line.

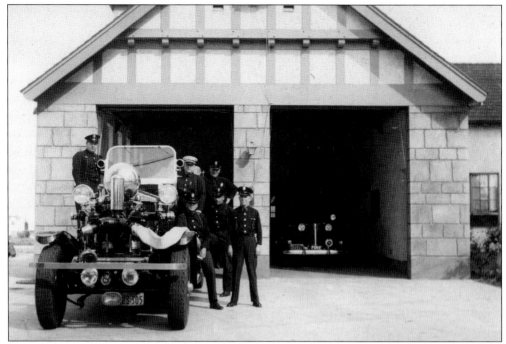

In 1939, fire Station No. 9 was reopened in a different location. The Works Progress Administration (WPA) started by Franklin Delano Roosevelt in 1935 built Station No. 9 and Station No. 7. This photograph was taken in 1940.

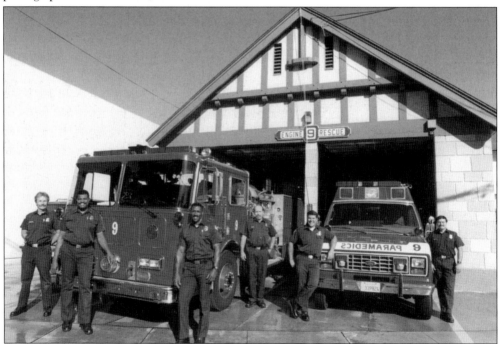

This picture of Station No. 9 was taken in 1986 and shows how little it has changed. The crew, from left to right, is Mike O'Neil, Gene Willingham, Duaine Jackson, either Tom or Jerry Freeman, Paul Lepore, and Alan Patalano.

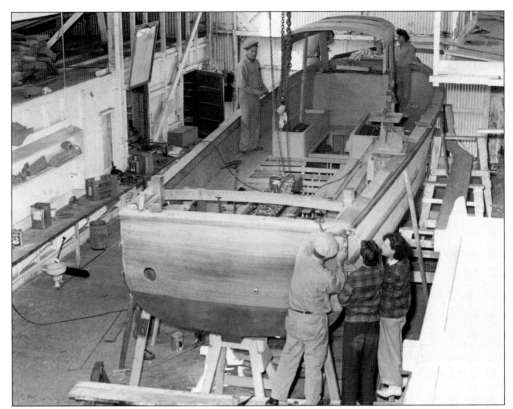

In 1942, the City of Long Beach commissioned the building of its first fireboat, the *Charles S. Windham*. The *Windham* was built by Wilmington Boats Works and financed by the Harbor Department. In the 1909 city audit report, Charles S. Windham was listed as mayor and fire commissioner for the City of Long Beach.

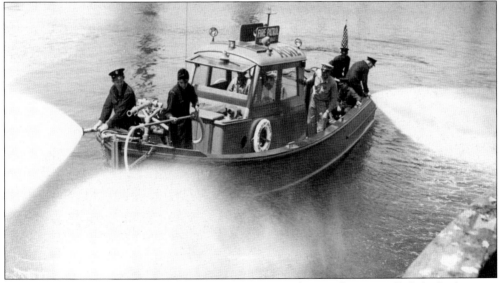

On May 8, 1942, the fireboat was placed into service. The *Windham* patrolled the harbor area from sunset to sunrise until the U.S. Coast Guard had sufficient resources to take over.

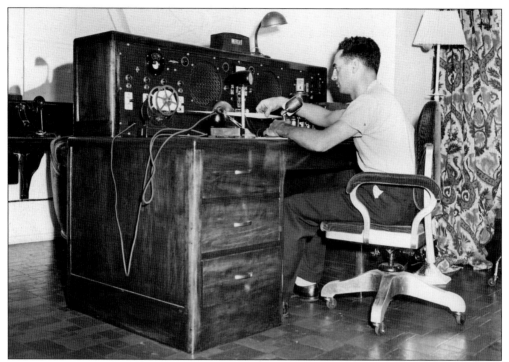

From 1942 until 1945, the alarm office was moved to the 15th floor of the Villa Riviera Hotel because of the ocean view, and it was thought that the hotel was more secure. Mr. H. Beaver is sitting at the alarm desk.

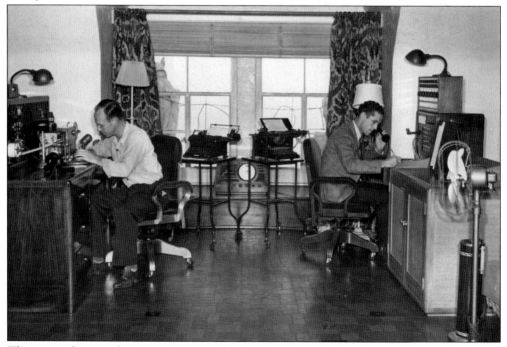

The gargoyles can be seen just outside the windows of the alarm office at the Villa Riviera Hotel.

On February 25, 1942, an anti-aircraft shell was accidentally discharged and hit a bank building near the intersection of Long Beach Boulevard and Market Street in the northern part of the city.

Fire Station No. 7 has changed very little since this photograph was taken in 1941.

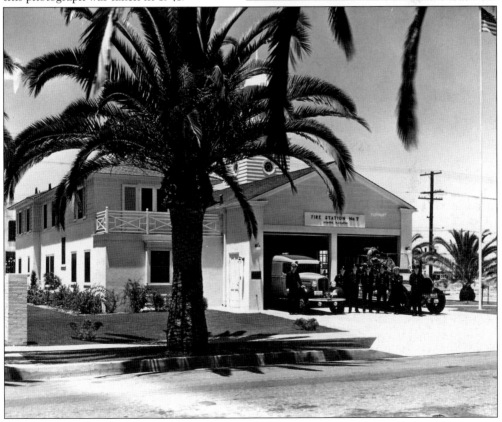

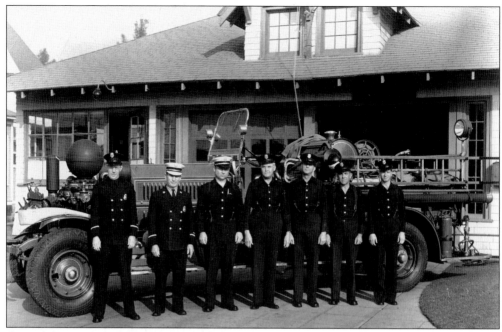

One of the more prominent features of the fire trucks was, and still is, the use of nickel and chrome plating. During the war years, we had to "black out" most of the shiny plated surfaces on all of our equipment—like this Ahrens-Fox pumper at Station No. 2 in 1943.

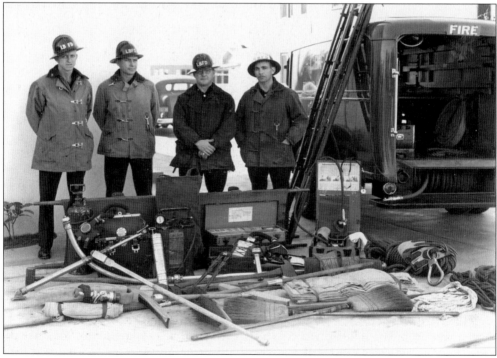

This is a picture of a GMC panel truck that was used as a first aid and salvage wagon. Here, the crew stands behind the type of equipment that it carried. The crew, from left to right, are firefighters George Mathews, Leonard Foster, Henry Kern, and Capt. Don DiMarzo.

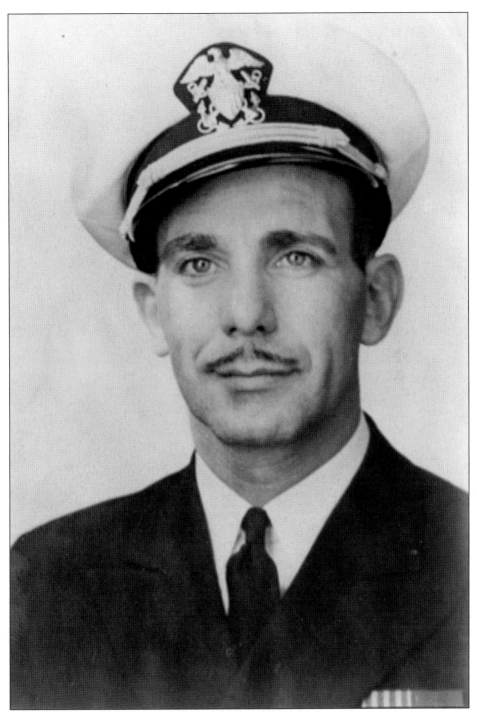

Almost 20 percent of the firefighters in Long Beach were called to duty during World War II. Don DiMarzo, pictured in his U.S. Navy uniform, was assigned to the USS *Intrepid*. The *Intrepid* saw fierce action in the Pacific and was involved in several battles. During one of these fights, Don DiMarzo lost his life helping extinguish a fire onboard ship. He was the only Long Beach firefighter who left to join the military to die in the line of duty during World War II.

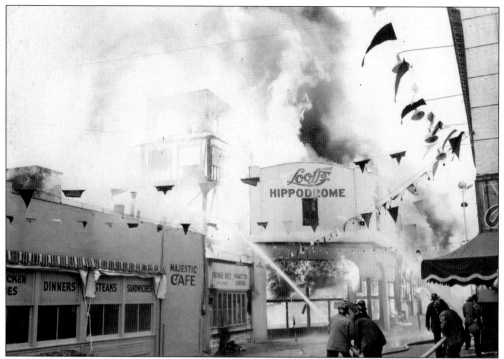

In 1902, Charles Drake started to develop the "Pike" amusement area along the coast of Long Beach. On July 14, 1943, the Looff's Hippodrome caught fire.

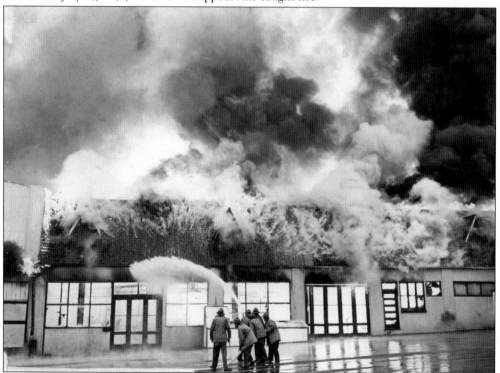

Several of the buildings became fully engulfed making it a very stubborn fire to put out.

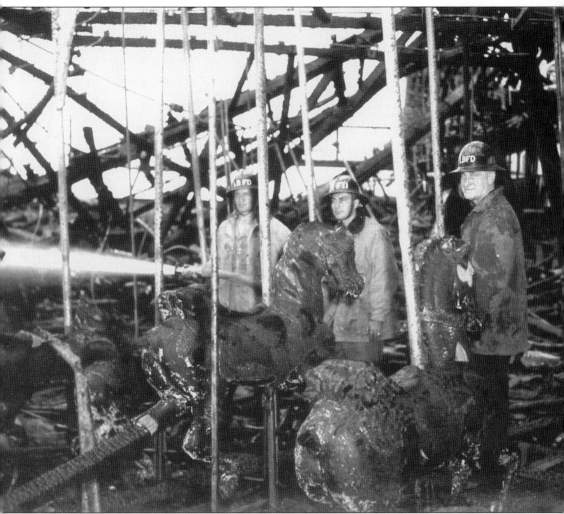

The saddest moment during the fire was when Looff's Carrousel, built in 1911 by Charles I. D. Looff, a famous carrousel builder, was completely destroyed. A replacement was built and remained until 1979.

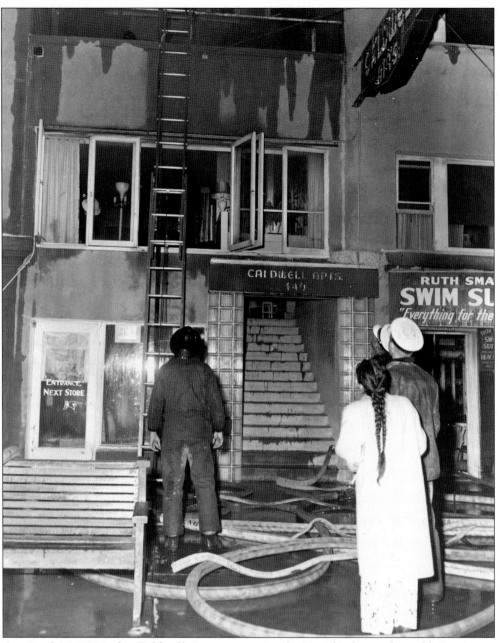

On April 24, 1944, the Caldwell Apartment complex caught fire and quickly grew to a three-alarm blaze. The fire lasted 11 hours and left 30 families homeless. The total fire loss exceeded $100,000.

In the beginning, it seemed that the Caldwell Apartments fire started in the elevator shaft, but it was soon discovered that the fire was arson. The arsonist was caught less than a month later, and he confessed to the crime.

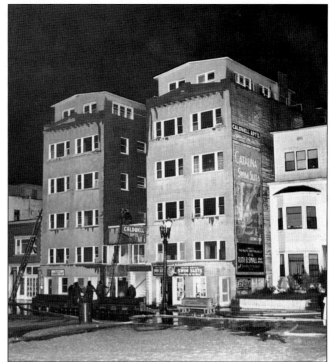

There was a large military presence in the city during World War II. Here, firefighters put out a military tank fire near the intersection of Market Street and Dairy Avenue in 1944.

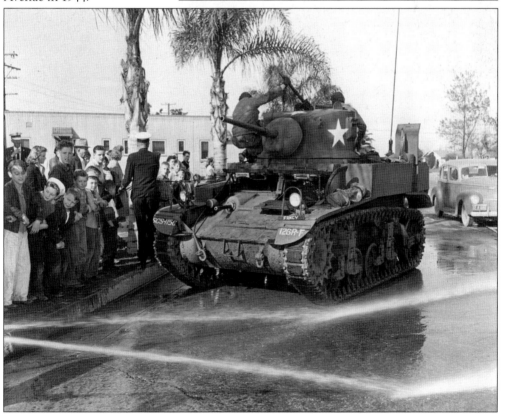

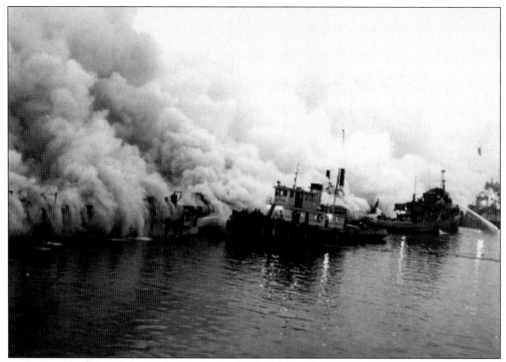

In 1945, most of the piers and docks were built of wood, and a fire that involved the docks would become a major disaster. One of the biggest challenges the firefighters faced was directing the hose streams up under the docks.

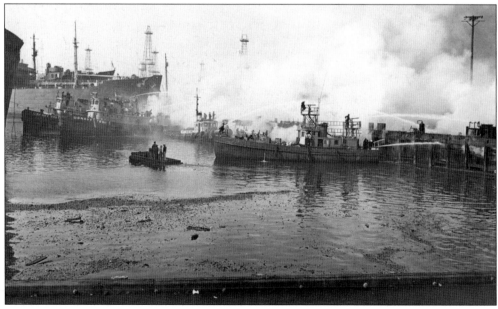

On December 5, 1945, berths 52, 53, and 54 caught fire. It took 280 men 65 hours to extinguish the fire with mutual aid help from the U.S. Navy and Los Angeles Fire Department fireboat no. 2.

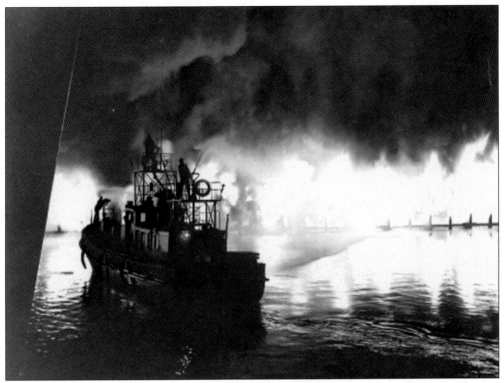

Night operations at the dock fires resulted in some excellent pictures.

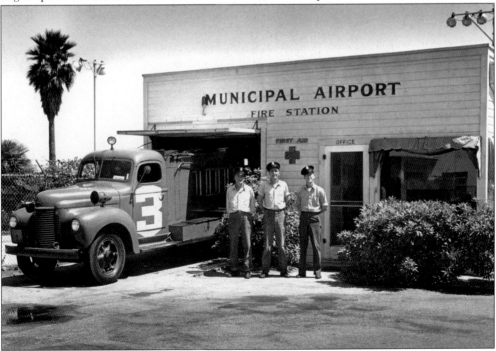

This unidentified crew stands in front of the fire station at the Long Beach Municipal Airport in 1947. The Douglas Aircraft Company donated the building.

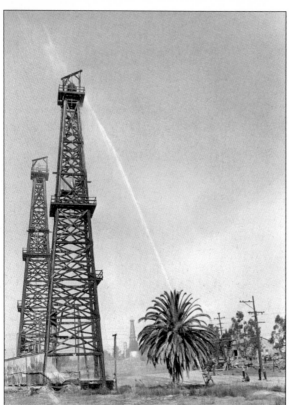

The firefighters trained often in the oil fields in order to keep up with the rapidly changing oil industry. This picture was taken in 1946.

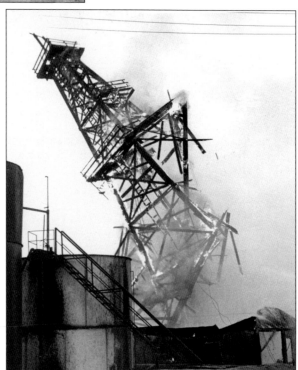

In 1946, there were still wooden derricks in the oil fields, and when they were on fire there was always the danger of collapse.

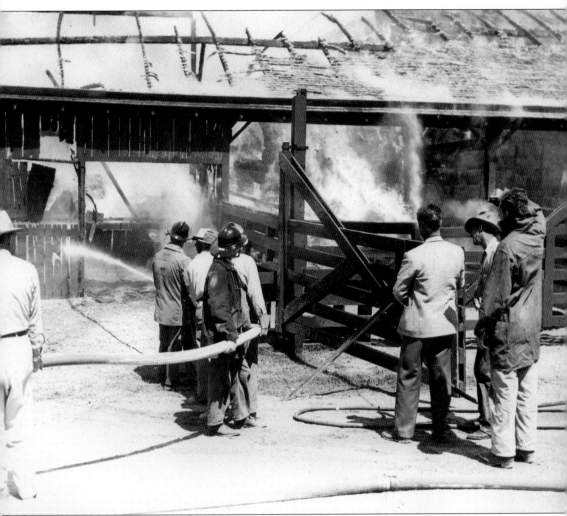

The Bixby family, who ran a successful sheep ranch, owned much of the land that is now the city of Long Beach. In 1947, two barns and part of the corral were destroyed by fire. The buildings were rebuilt and now this portion of the ranch, including the main house, is a historic landmark open to visitors.

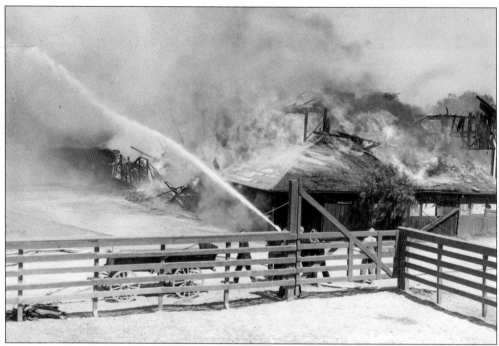

Ranch hands and private citizens manned the hose lines until the fire department arrived.

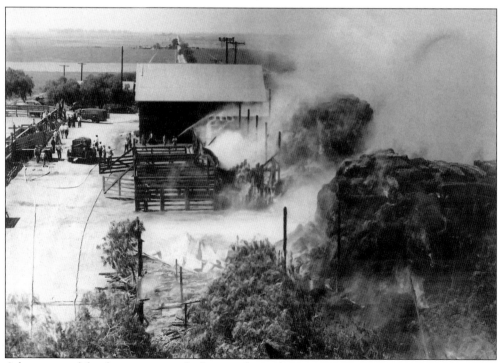

A large part of the damage was in the barn and corral area.

In November 1947, Howard Hughes took his airplane for what was supposed to be a test taxi on the water. Everyone was surprised when he took off and flew the plane. This photograph was taken from the fireboat as it stood by for the test.

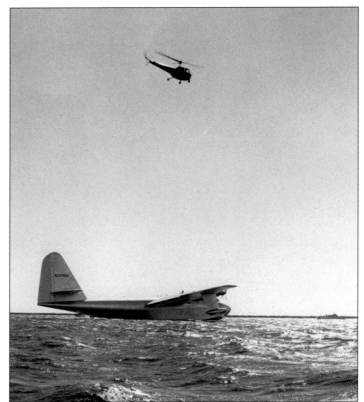

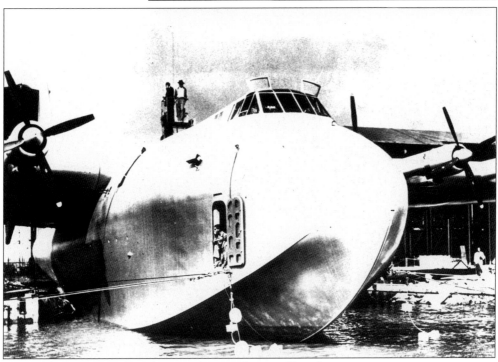

Pictured here is Howard Hughes standing on the top of his plane.

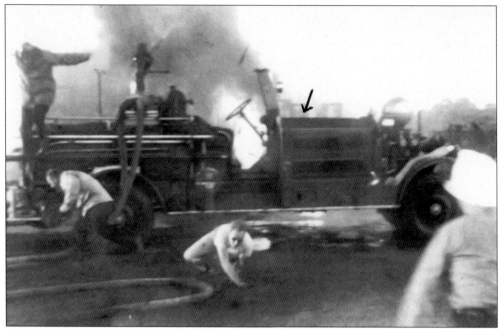

In 1950, a flaming barrel hits this 1929 Ahrens-Fox fire truck and caused the crew to jump off and run for cover. Pictured here, from left to right, are firefighters Shaw, Wolf, Slope, and Monroe. This was the last fire for the Ahrens-Fox; it served the Long Beach Fire Department from 1929 to 1950. The rig is housed in the Long Beach Firefighters Museum and will soon be restored.

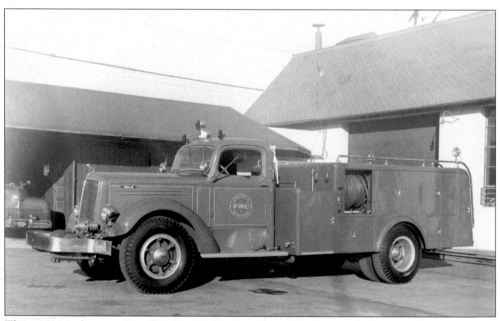

This 1950 Mack was assigned to Station No. 1 as Squad No. 1 and while responding to a minor garage fire on April 19, 1951, was involved in an accident with another fire truck. Rookie firefighter Marc Mimms was killed on his first run as a firefighter. Six other firefighters were injured.

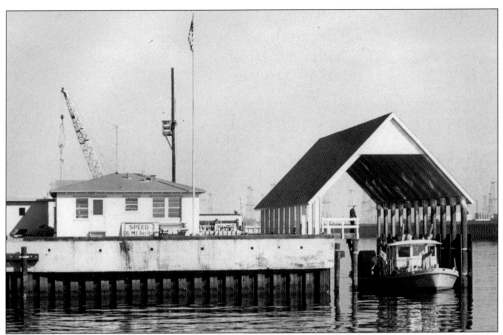

Pictured here in 1950 is the fireboat station and boathouse in the harbor.

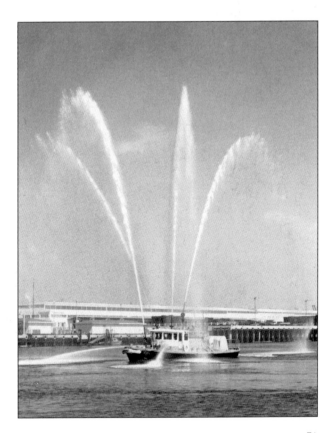

Fireboats are often asked to do water displays.

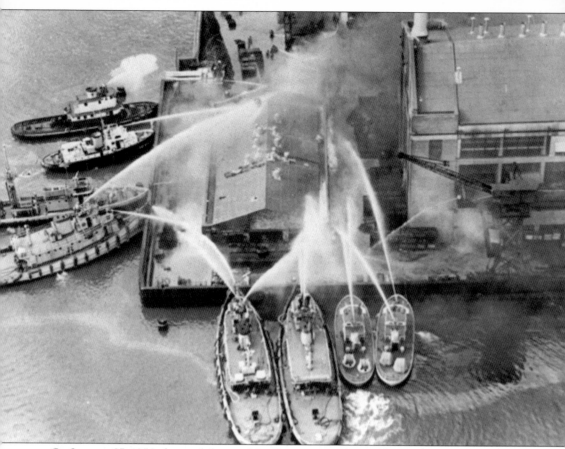

On January 27, 1956, the south levee of the Dominguez Channel burst 200 feet from Henry Ford Avenue, sending oily floodwaters into the Ford plant and shorting electrical circuits. Ford was in the process of moving to a new plant, and there were only a few employees present when the explosion occurred at 10:20 a.m. Firefighters and five fireboats from Long Beach, Los Angeles, and the U.S. Navy fought the blaze for five hours. The fire and water damage was estimated to be in the millions.

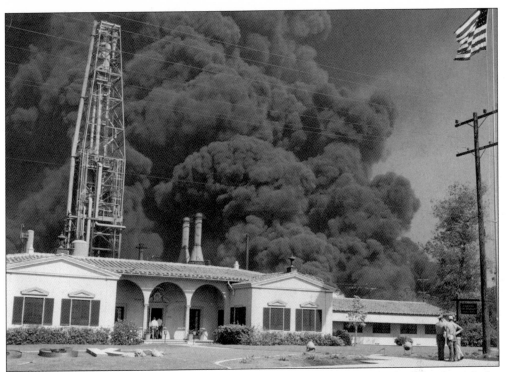

Hancock Oil Refinery tank no. 65 foamed over on May 22, 1958, causing oil to flow through the yard, and eventually find an ignition source.

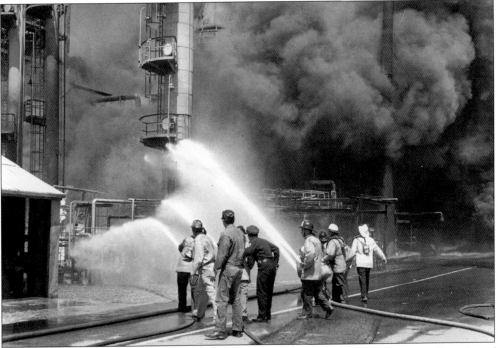

The Hancock Oil Refinery is located in the city of Signal Hill bordering the city of Long Beach.

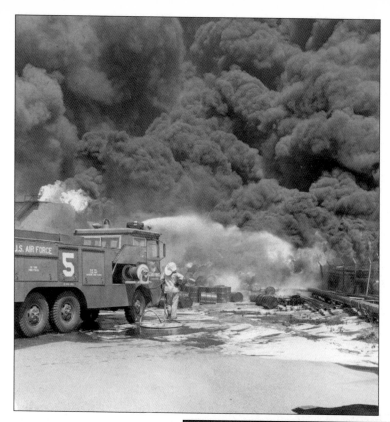

The call went out for mutual aid, and responding units came from Long Beach, Los Angeles, and the city of Vernon. Equipment was sent from the U.S. Navy and the Richfield Oil Company. Pictured here is one of three crash fire trucks sent by the U.S. Air Force.

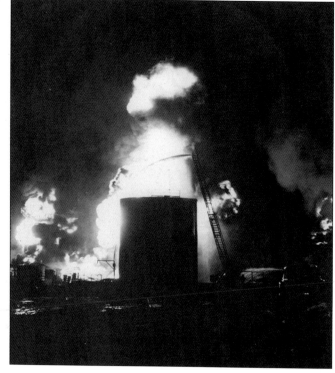

The Long Beach Fire Department was on the scene for 54 hours and used 74 men to combat the fire. There was heavy damage to four low-pressure natural gas tanks belonging to the City of Long Beach.

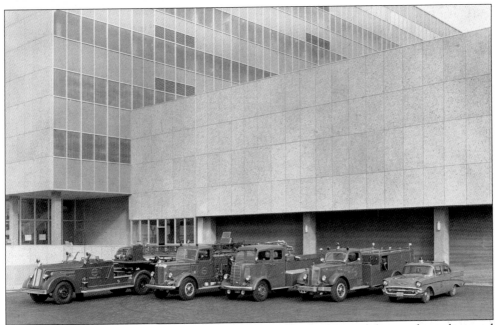

In 1959, the City of Long Beach built a public safety building to house the police and fire departments.

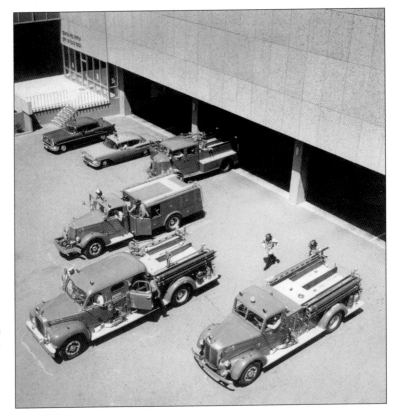

The units that were assigned to the new Station No. 1 were a squad, rescue, engine, and a hose wagon.

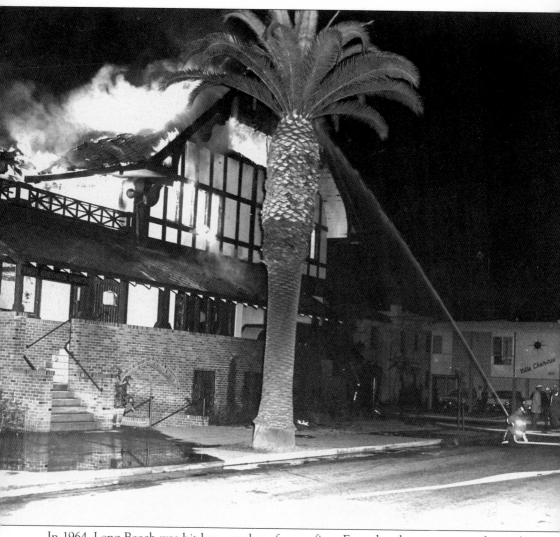

In 1964, Long Beach was hit by a number of arson fires. Four churches were set on fire with a total fire loss of $1,125,000. Here, the unidentified crew works to put out the church fire at Fifth Street and Cherry Avenue.

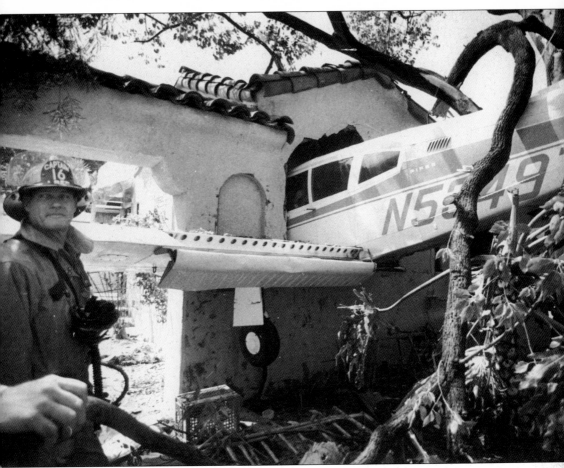

Living near an airport is not always safe. Here, a small private airplane pays an unfortunate visit to a home.

June 1964 saw the start of construction on a new alarm office on the north end of the same property where the old alarm center was located (on Peterson Avenue). The aged wooden training tower was nearby.

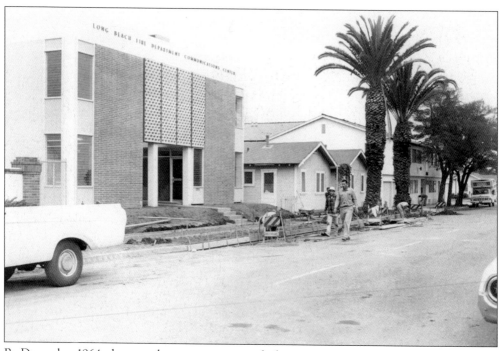

By December 1964, the new alarm center was ready for use.

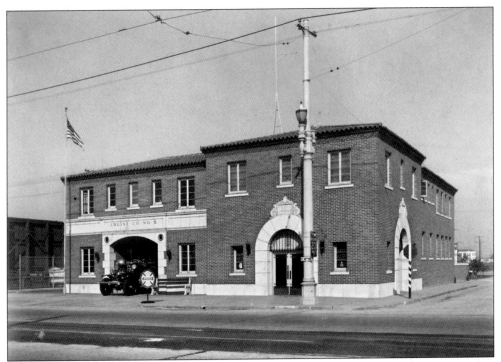

Station No. 8, built in 1929 in the Belmont Shore area of Long Beach, is still in service today. The left side of the building was the fire station and the right was the police station.

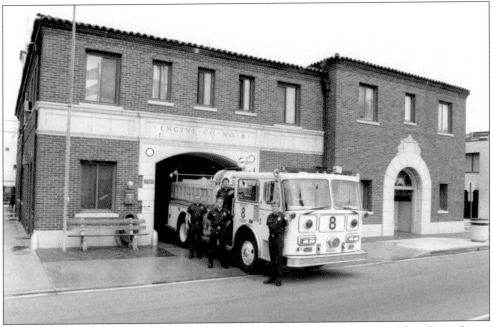

This is how Station No. 8 looks today. Pictured, from left to right, are crewmembers Lorin Jones, Chris Rowe, Ralph Morentin (standing on the step), and Capt. John Kirby.

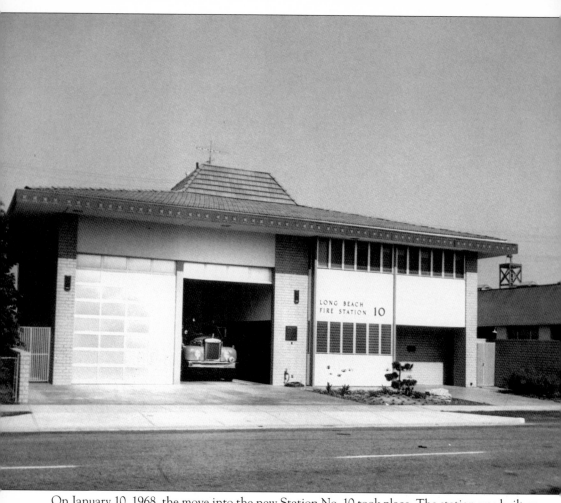

On January 10, 1968, the move into the new Station No. 10 took place. The station was built on the site of the old Fire College and alarm office.

Four

TRAINING

Up until 1924, firefighters were trained differently depending on the station to which they were assigned. In 1924, Chief Craw and Assistant Chief Minter adopted the Fresno Fire Department method of training firefighters. Fresno used one central training location and a training manual to achieve consistency. Station No. 6 was used as the first training center. Pictured here are unknown trainee firefighters.

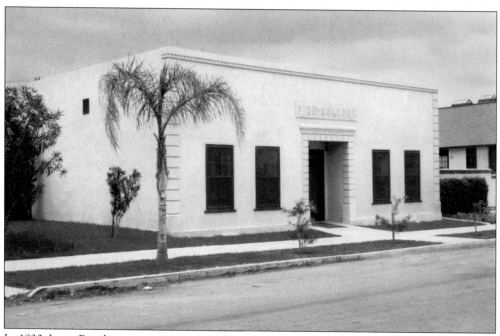

In 1930, Long Beach carpenters supervised the construction of the Fire College building and a wooden drill tower built by firefighters. Capt. E. Steiner was appointed as the first drill master.

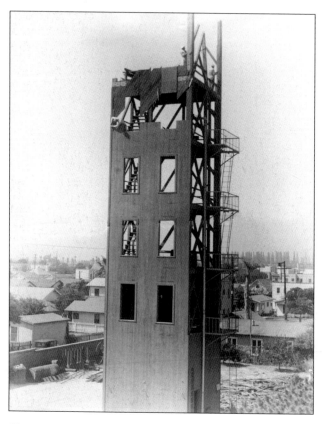

In 1940, the wooden drill tower extended to six stories.

In this 1939 picture, two unidentified firefighters practice a rescue with a breathing device that was said to last two hours.

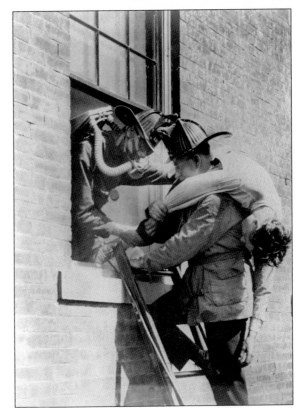

The classroom in the Fire College was small and could only accommodate 20 students. Here, instructors prepare lessons on fire ground hydraulics.

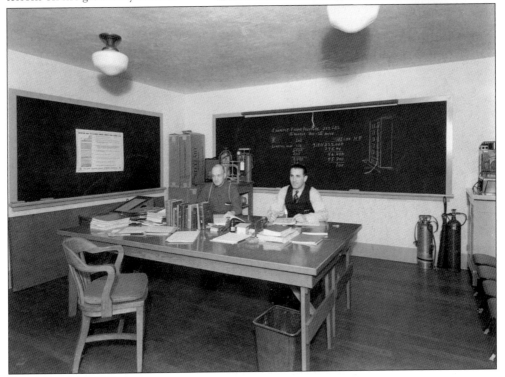

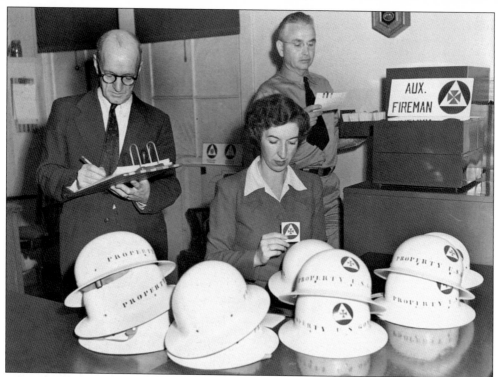

After the start of World War II, the fire department began to train the Auxiliary Fire and Rescue Service. Pictured here, from left to right, are Capt. Harry Lucas, Nancy Brooks, and Battalion Chief Radcliffe, who were in charge of training the auxiliary firefighters.

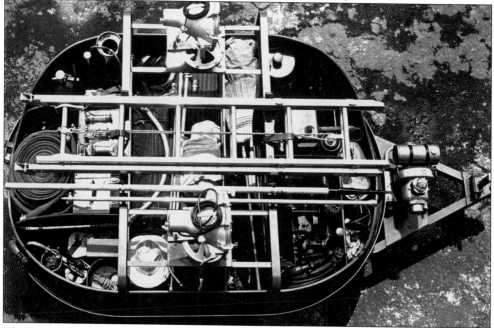

This is an Emergency Trailer Unit; it contained a pump and other tools for the auxiliary firefighters.

In 1941, almost 600 men volunteered in to be in the Auxiliary Fire and Rescue Service.

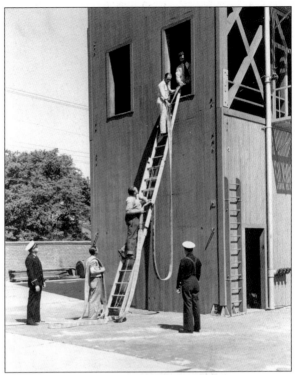

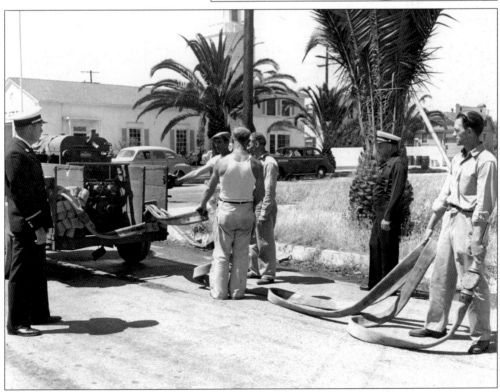

Here the unidentified auxiliary firefighters train with the Emergency Trailer Units.

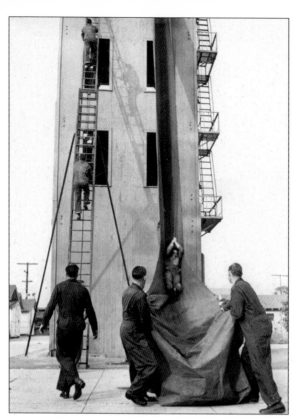

This *c.* 1945 drill class trains with an evacuation chute.

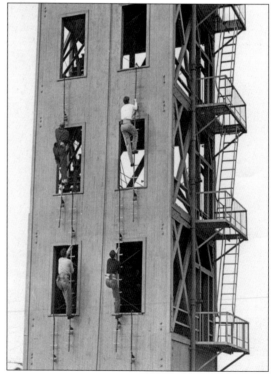

These 1945 recruits are training with single beam ladders, or Pompier Ladders as they are sometimes known. This ladder was used by firefighters to go from floor to floor on the outside of a building. By placing the hooked end of the ladder on the window ledge above and climbing the narrow ladder up to that floor, the firefighter could use the same ladder up to the next floor and so on.

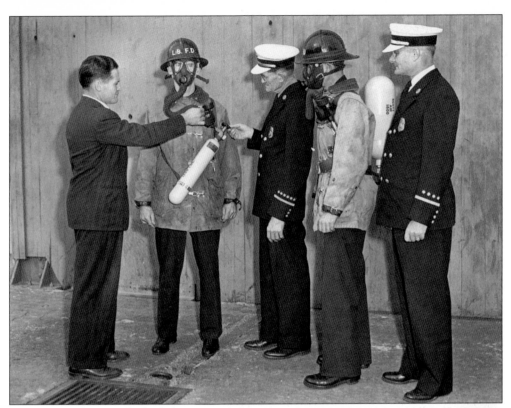

In this 1946 photograph, firefighters receive a demonstration on a self-contained breathing apparatus.

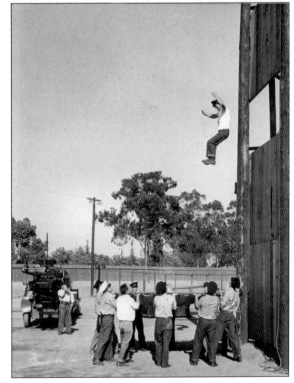

Life net training was an important part of new firefighter training. The firefighters would train with the life net during the first few days of drill school. If they refused to jump into the net they failed drill school.

This 1947 picture shows the Fire College, Station No. 10, and the wooden training tower in the background. In 1964, the new alarm office was built where the wooden tower is, and four years later Station No. 10 was built where the Fire College was located.

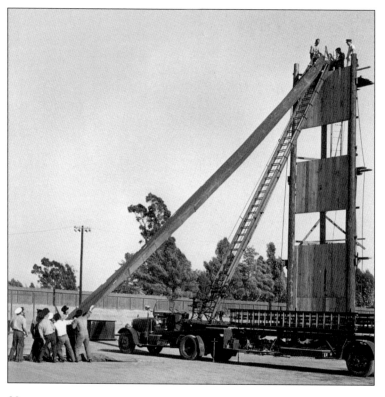

In 1947, the firefighters put on a demonstration of the evacuation chute at Recreation Park. In 1964, firefighter Kent Holliday died when he fell from the evacuation chute during training.

One of the most difficult things to do at a dock fire was to direct the water stream up under a wooden dock or pier. In this picture, an unidentified boat crew trains with a floating nozzle that would spray water up.

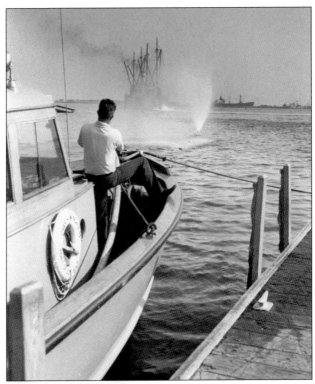

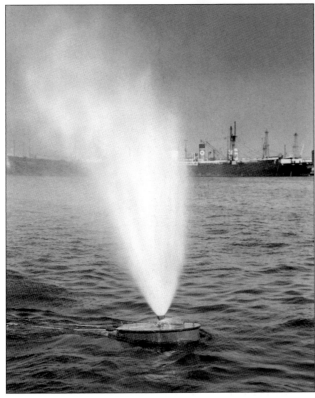

Here is a closer view of the floating nozzle.

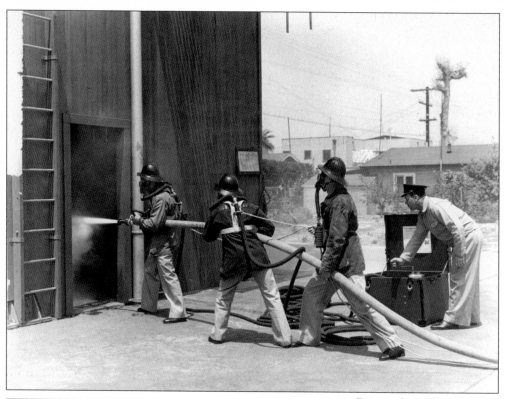

During the 1950s, firefighters train with a dual air pump device. Two firefighters would put on breathing masks that were connected by a hose to a single air pump and another would turn the hand crank to operate the air pump.

This is a closer view of the dual breathing mask that the firefighters would wear.

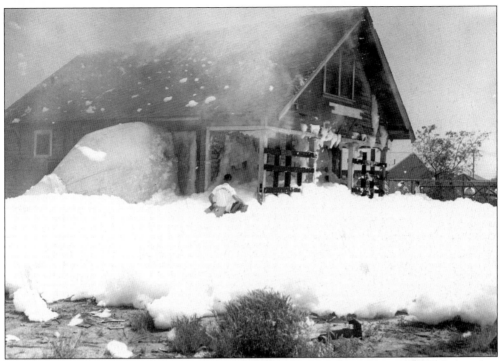

In this 1965 photograph, firefighters train with high expansion foam. It is used to help smother a fire in an enclosed space, such as a house, as seen here.

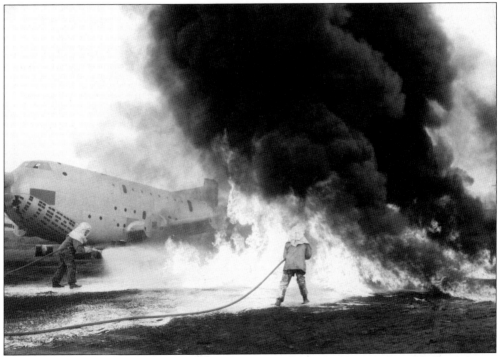

The airport fire crews train with a prop to simulate an aircraft fire. At one time, the city of Long Beach had one of the busiest private plane airports in the nation.

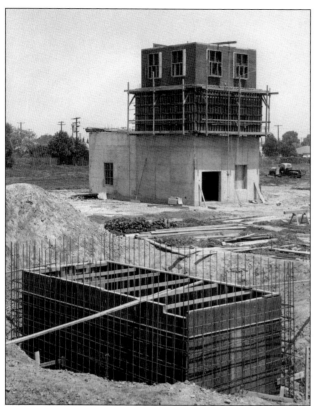

The citizens of Long Beach voted for $1,535,000 of improvements, and part of this went to a new training center. In this 1963 picture, you can see a six-story concrete tower being built with a drafting pit in the foreground. A drafting pit is an underground pit of water used to practice pumping and test fire truck pumps.

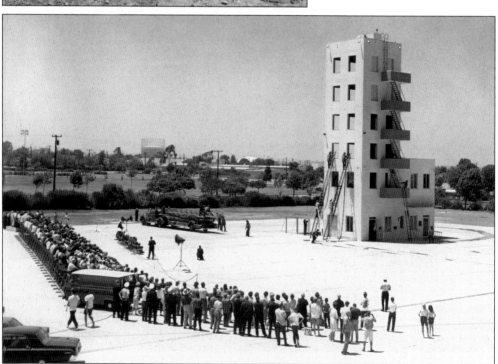

In July 1964, the first drill class from the new training center graduated.

Five

FIRST AID

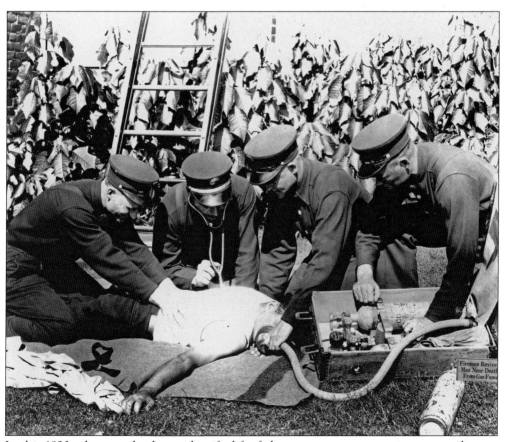

In this 1920s photograph, the unidentified firefighters use oxygen to revive a man who was overcome with gas fumes.

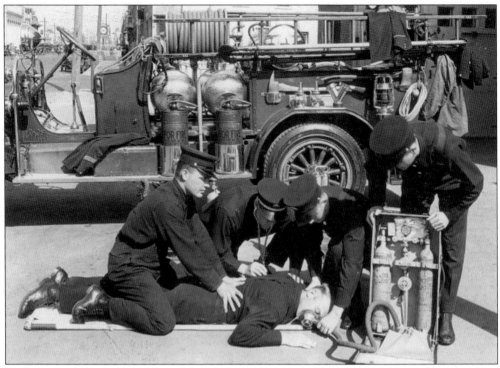

In this 1920s or early 1930s photograph, firefighters practice an early form of cardio pulmonary resuscitation (CPR).

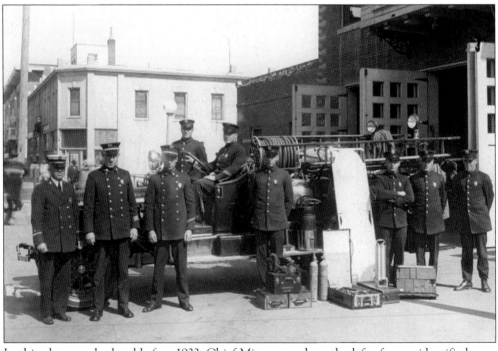

In this photograph, dated before 1933, Chief Minter stands to the left of an unidentified crew displaying the first-aid equipment carried by the Long Beach Fire Department.

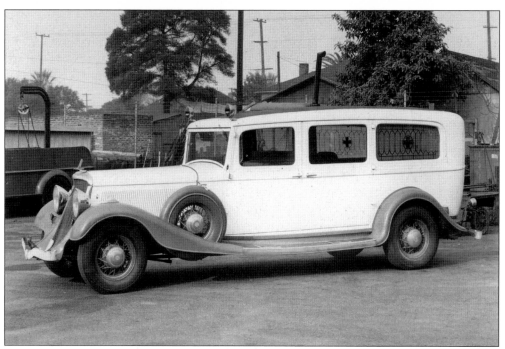

Before 1941, private companies provided the ambulance service for Long Beach. This is a picture of a 1934 Studebaker ambulance.

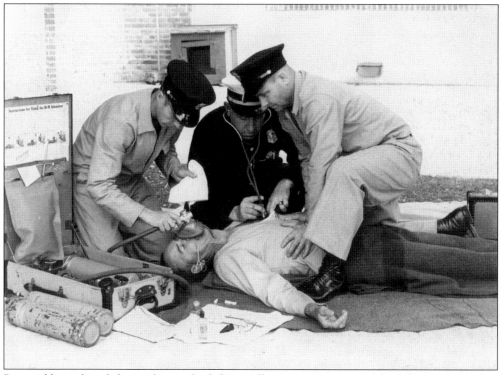

Pictured here, from left to right, are firefighter Tally, Captain Davis, and firefighter Tyler as they practice first aid on the "patient"—firefighter Corrigan.

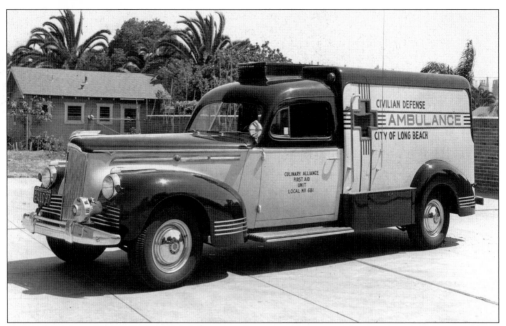

During World War II, the Civil Defense Ambulance Service operated with donated ambulances. The Culinary Alliance Local No. 681 donated the ambulance seen here.

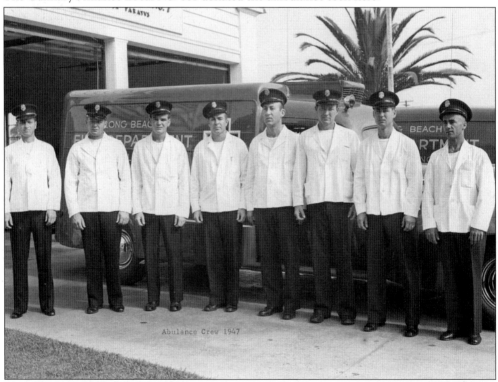

Seen here in 1947 is the ambulance crew at Station No. 7. From left to right are Bob Moll, Morris McCuen, Ted Klobucher, Garret Cady, George Carver, John Olson, Dale Lowell, and Al DeFrank.

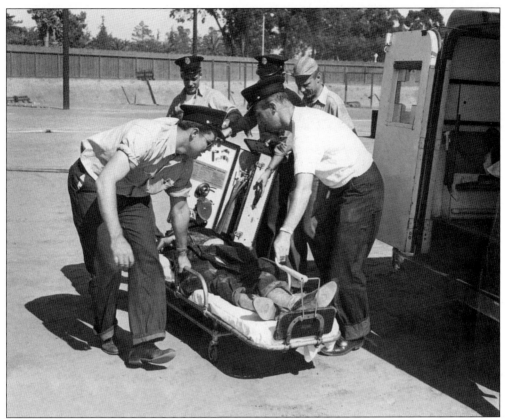

At Recreation Park in 1947, unidentified firefighters demonstrate a rescue at a firefighting presentation.

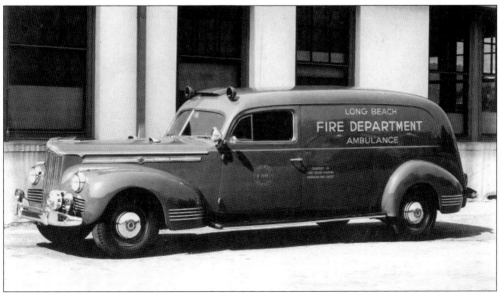

This is the 1948 Packard ambulance that the fire department used.

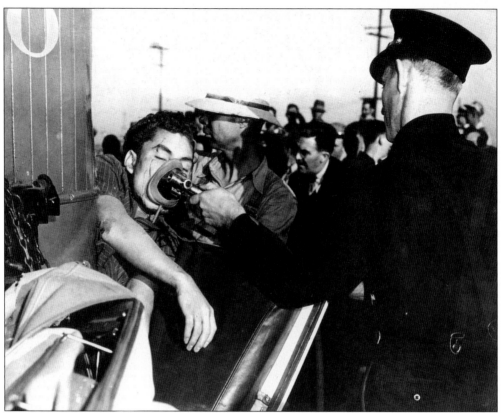

In this *c.* 1950 picture, a patient is rescued from a trolley accident.

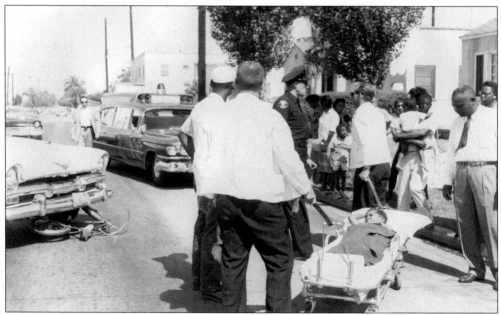

In the late 1950s, the fire department ambulance crew transported this child to the hospital.

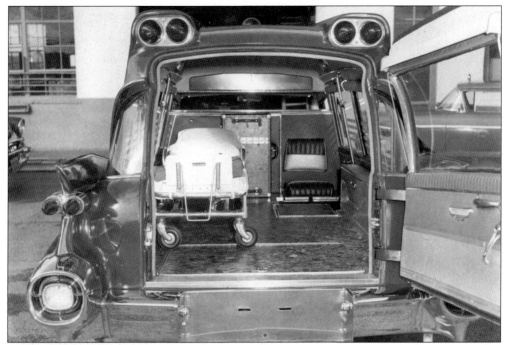

In the 1950s, the Long Beach Fire Department started using Cadillacs for ambulances. Here is an interior rear view of one of the Cadillacs.

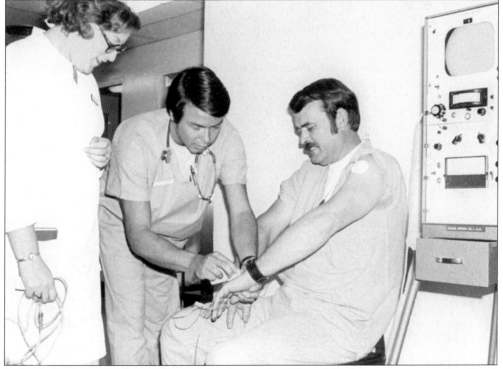

In 1972, the Long Beach Fire Department sent its first class of firefighters to paramedic school. Here, John Acosta and Bob Parkins practice inserting IVs.

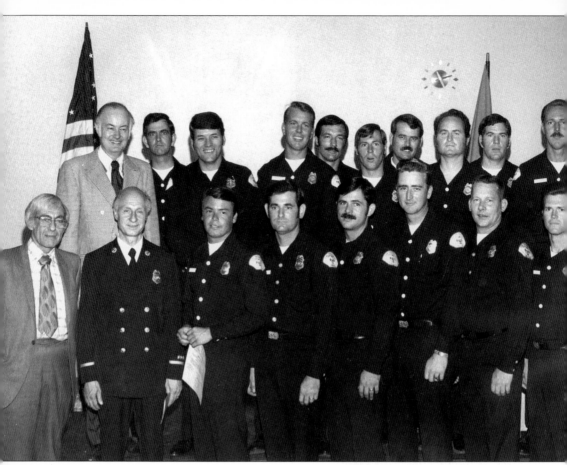

The first paramedic graduating class is pictured here in 1972. They are, from left to right, as follows: (first row) Dr. Irv Unger from Saint Mary's Hospital, Chief Rizzo, John Acosta, Art Santavicca, Gary Olson, Pat Highfill, Dennis Weller, and John Christensen; (second row) city manager Bob Creighton, Bill "Mad Dog" Kelly, Walt Gupton, Don Aselin, Bob Shue, Craig Vestermark, Bob Parkins, Gary Robertson, Dennis Wynn, and Carl Scheu. The first paramedic vehicle was a converted plumbing truck.

Six

ODDS AND ENDS

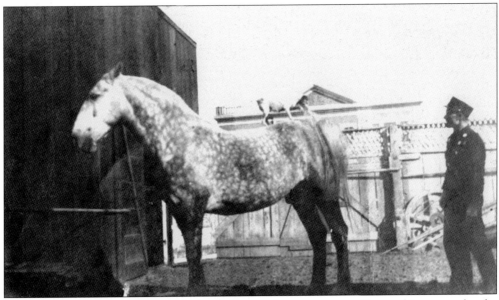

George Hocking had the duty to care for the horses; there were seven. Tom and Jerry, two dapple-grays, pulled the engine. King and Prince, both coal black, were assigned to the hose wagon, and assigned to the ladder truck were two bays named Major and Colonel. Barney, the seventh horse, was used to fill in when the other horses had a day off. Barney was quite the prankster—he learned how to open all the horse stalls and let the other horses loose. When he heard someone coming though, he would enter one of the stalls as though nothing happened.

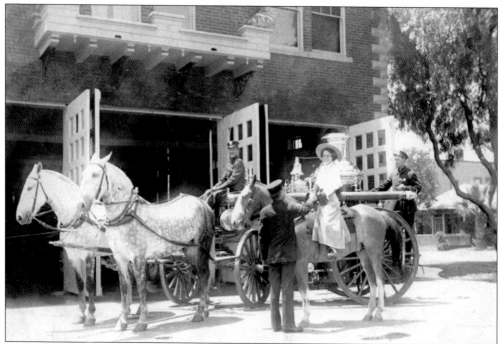

In 1911, a local actress posed for a publicity photograph sitting on a horse next to the Metropolitan steam engine in front of Station No. 1. The names of the actress and the firefighter are unknown.

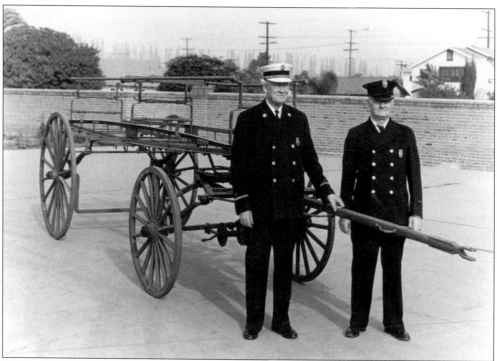

Pictured here in 1941 are retired Battalion Chief J. R. Buchanan and retired engineer George Hocking standing next to the 1902 hand-drawn ladder.

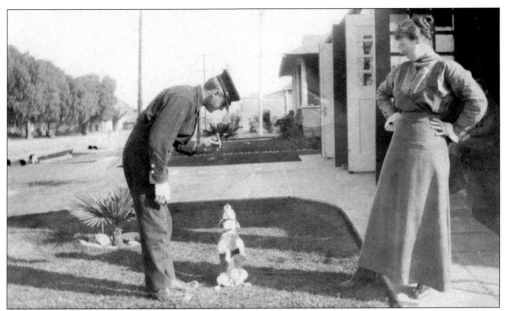

The first known fire department mascot was a little dog named Digger, shown here in 1917 at Station No. 2 with firefighter H. Foulke and an unknown female. Fouke left the fire department in 1918 to join the U.S. Army.

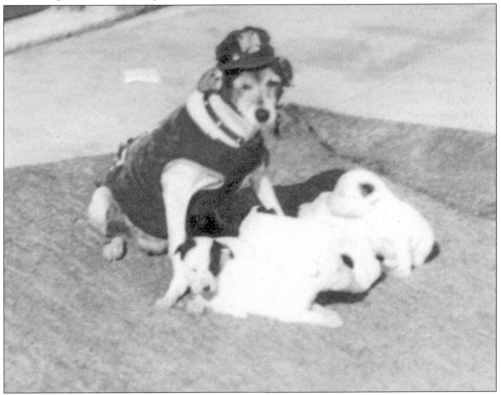

Digger had a uniform cap and coat, and lived mostly at Station No. 2. He eventually passed away in 1924, and his Digger's service cap and coat are on display in the museum.

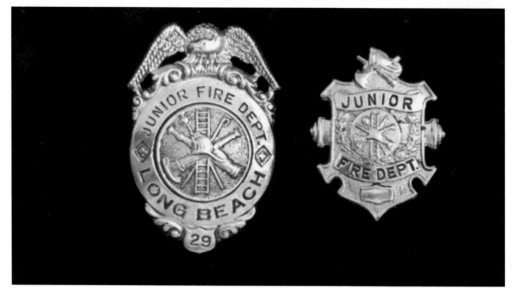

In 1926, Chief Minter created the Long Beach Junior Fire Department, very close to today's fire explorers, a program for teenagers to learn the fire service and first aid. Pictured here are the badges they wore.

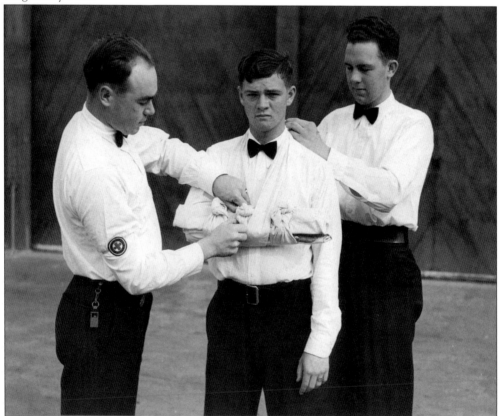

Practicing arm splinting in 1929, from left to right, are Wilford Woodbury, Roy Hamilton, and W. S. Minter Jr., the chief's son.

This is W. S. Minter Jr.'s Long Beach Junior Fire Department membership card.

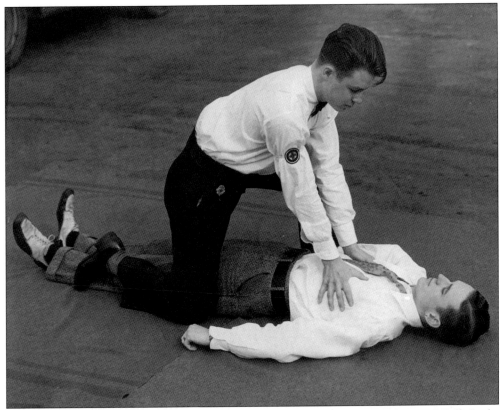

Practicing the Shaefer method of resuscitation in 1929 are Earl Milan and Bill Stuht (lying down).

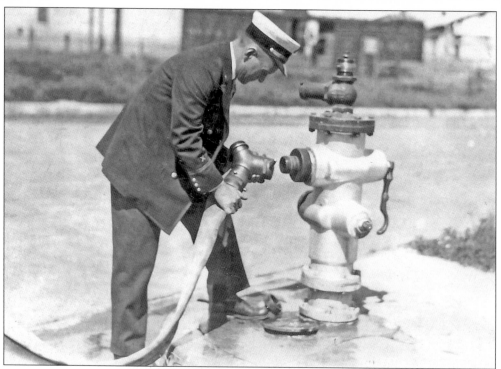

Battalion Chief Harry Lucas is demonstrating a hydrant fitting he invented for the fire department in the late 1920s and early 1930s. This fitting is unique to the Long Beach Fire Department, and has been so successful that it is still in use today.

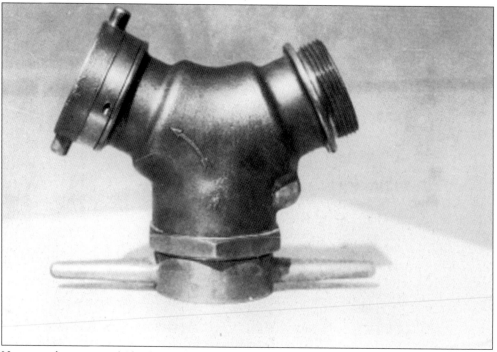

Here is a closer view of Chief Lucas's hydrant fitting.

In 1931, the obsolete alarm bell was removed from the tower behind Station No. 1.

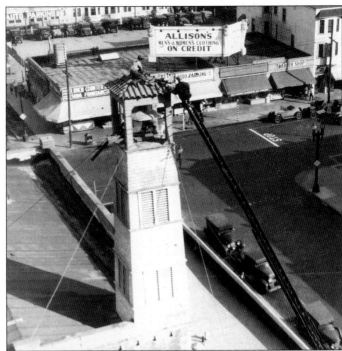

In 1942, the old alarm bell was scrapped for the war effort.

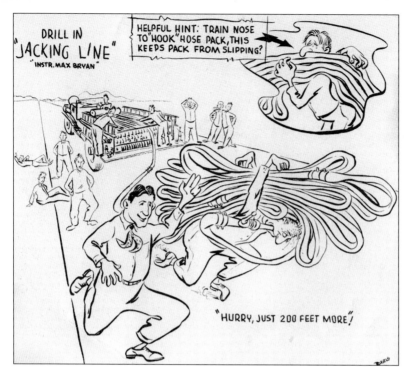

Firefighter Ed Rugals was a talented cartoonist who often drew cartoons of the men and goings-on of the department. This cartoon from the 1940s shows drill instructor Max Bryan teaching the recruit how to "jack a hose line."

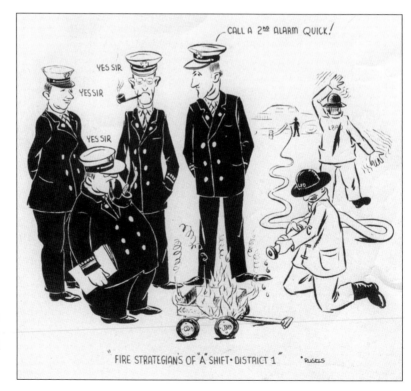

This cartoon, also drawn in the 1940s, is poking fun at a District 1 "A" shift strategy session.

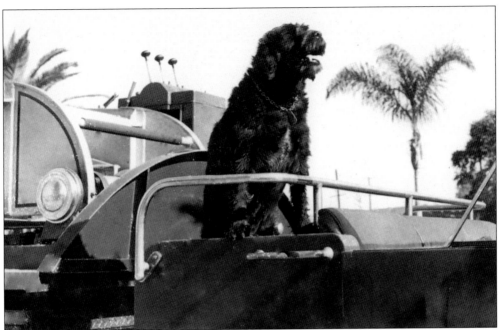

Another department mascot was a dog named Bimbo, seen here in 1955 sitting on a ladder truck.

When the alarm sounded, Bimbo often beat the crew to the rig. Bimbo also helped train new firefighter recruits at the training center.

Seen here in 1941 are firefighters R. Plumb and H. Kern pulling kitchen duty at Station No. 7. Today in the Long Beach Fire Department, the whole crew takes a turn cooking—even the "bad" ones.

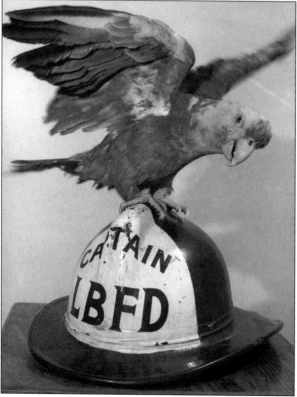

Here is Cully Churchfield's pet parrot. Churchfield was a non-sworn employee and, during the mid-1950s, could be seen around the maintenance shop.

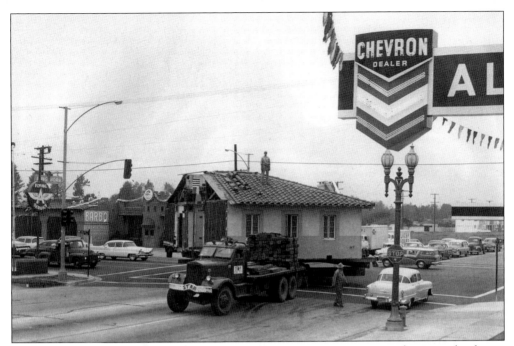

On December 4, 1957, Station No. 13 was moved from Santa Fe Avenue on the west side of town to the rapidly growing east Long Beach area, and renamed Station No. 18. Engine No. 18 had to be temporarily housed at Station No. 17 until the move was complete.

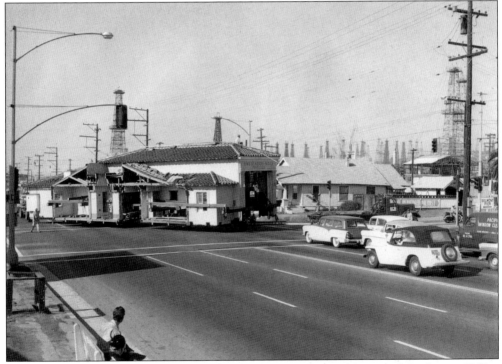

On December 6, 1957, the apparatus bay was moved and reassembly started. In August 1957, a new Station No. 13 was built on Adriatic Avenue.

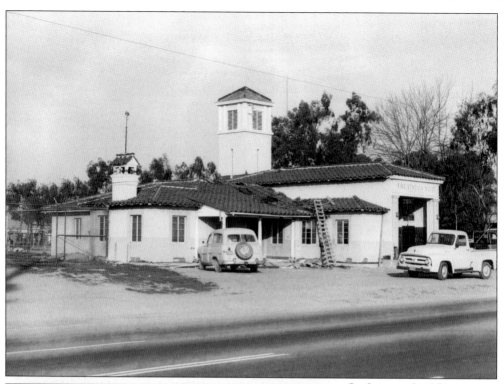

On January 8, 1958, the fire department was allowed to move into the new Station No. 18.

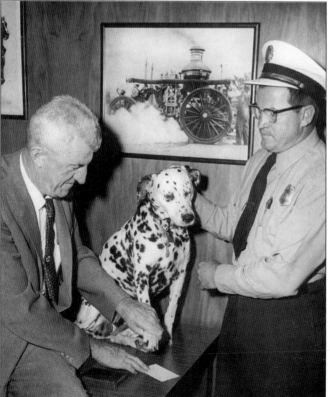

While the traditional firehouse dog is the dalmatian, Long Beach had two other breeds before finally getting their dalmatian mascot, Duchess. Seen here in 1958 is Duchess being "paw-printed" by Chief Sandeman and an unidentified battalion chief.

Duchess is at rest in her favorite chair at Station No. 7 in 1958 waiting for the next alarm.

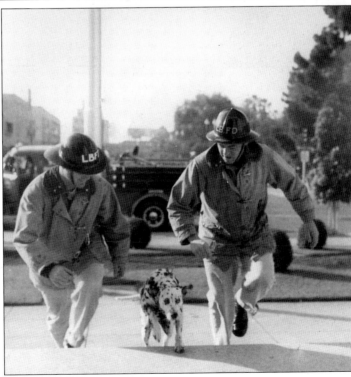

Pictured here in 1958, from left to right, are George Brown, Duchess, and Art McIntyre running up the steps to city hall.

This *c.* 1963 photograph proves that firefighters do rescue cats from trees. The cat is near the end of the ladder where the tree bends at the top.

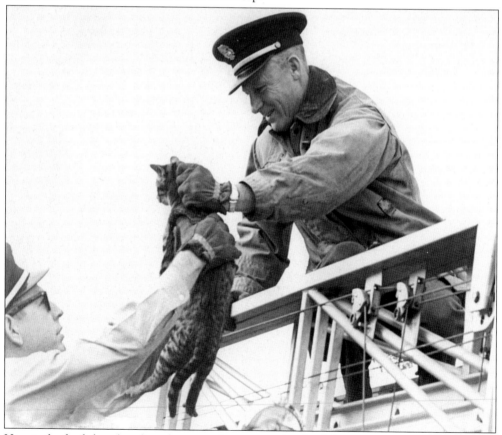

Here is the firefighter handing the rescued cat to another firefighter.

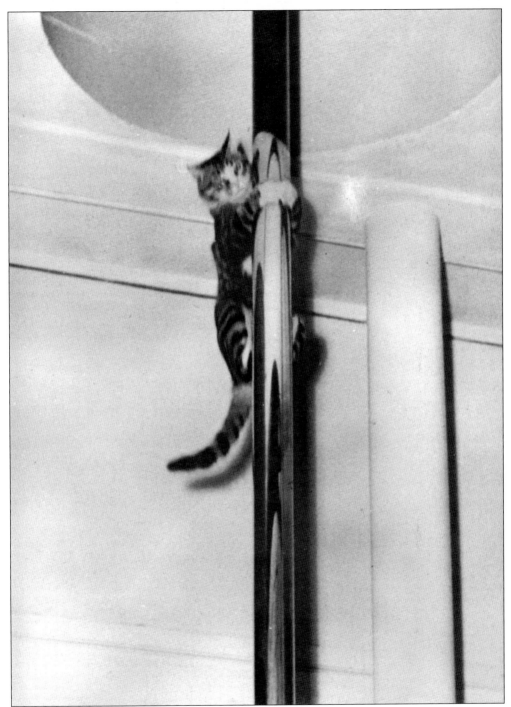

The most famous of the Long Beach Fire Department mascots was Sam the cat, who lived at Station No. 6. One day Sam was chased and he used the fire pole to escape. From that day on, Sam would slide down the pole on his own. After the local press picked up the story, Sam quickly became an international star. *Ripley's Believe It or Not* even ran a story on Sam. Sam started to receive fan mail and donations for his care.

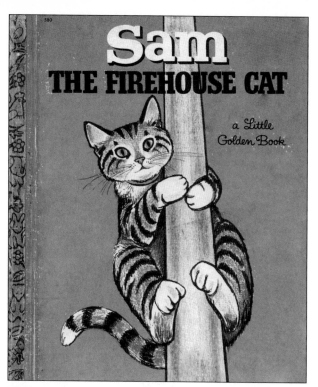

Golden Books and author Virginia Parsons published a children's book about Sam and his adventures at the fire station.

Famed Firehouse Cat Gone

★★★ ★★★ ★★★ ★★★ ★★★

Pole-Sliding Sam on the Town--They Hope

Jan 15, 1964

By VERA WILLIAMS

Sam is missing! ! !

Sam is the handsomest, most talented firehouse cat in the world—the only cat on land or sea that slides down a 20-foot brass fire pole. (At least, we think he's the only one).

Sliding Sam, for six years the mascot of Long Beach Fire Station No. 6, gained international fame with his sliding act. He slid onto page 1 of newspapers in the U. S. and abroad, and he was on magazine covers (in color, no less), was "interviewed" on television. He received a flock of fan mail, usually addressed to "Sam, Fire Station, Long Beach, Calif."

★★★

BUT SINCE DEC. 23, Sam has been missing. He isn't in any of his usual haunts around the station at 835 Windham Ave., in the heart of the harbor district.

He hasn't showed up at the City Animal Shelter. Nobody has seen him.

"We thought for quite a while Sam was just off visiting lady cats," said Dan Robichaud, a fireman who usually gave Sam his chow.

"Or chasing rats or gophers," put in Capt. Robert Moll, who customarily answered Sam's fan mail.

"A lot of traffic around here," one fireman said. "You don't suppose a truck or fast car—?"

"Sam always was smart about traffic." another offered quickly. "He looked both ways before he raced across the street."

★★★

SAM'S PICTURE hangs on the station wall. Below it, on the table, lie his mail including a Christmas card, and his red leather collar with the tag, "Sam, Fire Station No. 6." (Sam didn't like his collar, and firemen often took it off).

His dish is in the kitchen. The rug he slept on still lies in his corner of the TV room. Nobody has put them away, because they all hope Sam will show up.

Fireman Leslie Whalen brought the tiger-striped, yellow-eyed kitten to old Fire Station No. 6 which was a two-story structure, with a pole, at 1335 W. First St.

He was named Sam, given mascot first class rating, and had the run of the place.

A bulldog, it is said, chased Sam—and Sam slid down the pole as he saw the firemen do. From then on, he slid regularly, legs around the pole, claws sheathed.

★★★

REPORTERS GUSSIED up the story, as reporters sometimes do, and swore that every time Sam heard the alarm he went down the pole ahead of the firemen.

Firemen say that isn't so. Sam slid down the pole—alarm or not—any time he wanted to. Maybe a dozen times a day.

When fire equipment clanged. Sam watched the men go. He never rode the trucks.

Two years ago when Engine 6 moved to the harbor, it was housed in a new one-story structure. No pole to slide on.

Maybe that's where Sam has gone—to hunt a pole.

If you see him, tell Fire Station No. 6

When Station No. 6 moved to a new location in the harbor area, Sam never adjusted. He left, never to return.

This is Station No. 6, where Sam lived and the infamous slide down the fire pole from the second floor to the first floor took place. Station No. 6 was built in 1922 and equipped for $36,923.

This is a photograph of John Makemson (far right) in his drill class in 1944. To his left is Robert Leslie. The others are unidentified. On December 10, 1976, Robert Leslie became chief.

In the early 1970s, John Makemson retired from Station No. 12. He bought a house across the street from the station and often visited the crews during his retirement. John passed away in the early 1990s, but this is actually where the story begins. Mysterious things have been happening at Station No. 12 ever since John's passing. Recently a drill school graduate with no knowledge of previous ghostly visitations was on his first night in the station when he experienced a particularly odd phenomenon. He was awakened by a shadowy presence near his bed, and when he tried to sit up, he felt a light pressure on his chest holding him down. He could see the rest of the crew sleeping in their beds when this happened. Were these just firefighter pranks? Some say yes. Some say that John visits the station. John did once say, "I'll dance on their graves."

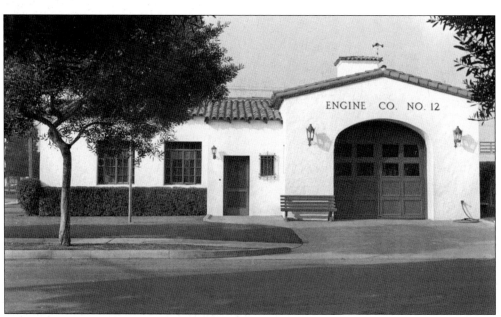

This is Station No. 12 as it looked in 1929 when it was built. It looks the same today, and some even say it is haunted.

Seven

FIRE CHIEFS

Every fire chief for the Long Beach Fire Department has contributed to the rich history of the department. All the fire chiefs have risen through the ranks, with the exception of Chief Shrewsbury who was appointed chief in 1901. Chief Shrewsbury turned down offers to go to other departments for more pay. Chief Shrewsbury was part of a sad moment in the fire deparment's history with his untimely passing in an automobile accident.

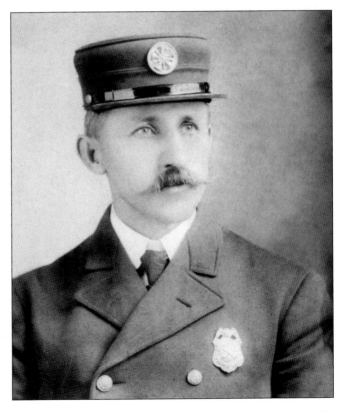

Joseph E. Shrewsbury
October 1, 1901–May 2, 1916

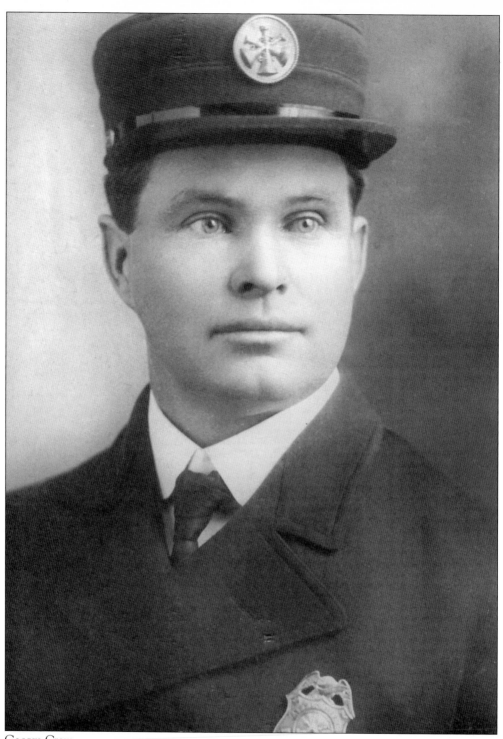

George Craw
May 2, 1916–March 1, 1926

William S. Minter
March 1, 1926–August 7, 1933

Allen C. Duree
August 7, 1933–February 1, 1946

Frank S. Sandeman
February 19, 1946–July 13, 1961

Leonard V. Foster
July 25, 1961–December 17, 1968

122

Tullio J. Rizzo
December 17, 1968–February 3, 1974

Virgil M. Jones
February 3, 1974–December 10, 1976

Robert E. Leslie
December 10, 1976–December 13, 1984

James B. Souders
December 13, 1984–November 2, 1988

124

Chris A. Hunter
November 2, 1988–December 31, 1993

Harold Omel Jr.
January 1, 1994–December 31, 1997

Anthon L. Beck
December 31, 1997–February 2, 2002

Terry L. Harbour
February 2, 2002–June 30, 2004

Chief Ellis has been chief of the Long Beach Fire Department for a relatively short period of time—June 12, 2004 to present—and has already begun to make his mark on what will be the history of the Long Beach Fire Department. Long Beach is a very diverse community with several industries; therefore, the Long Beach Fire Department must be highly trained and diverse itself. Today the Long Beach Fire Department has 502 sworn personnel and 23 fire stations including two fireboat stations and an airport station. In 1994, the Long Beach Fire Department merged with the Long Beach Lifeguards adding a Swift Water Rescue team and a dive team. Patrolling the harbor are two Marine Lifeguard Fire/Rescue boats, four Marine Safety Response vehicles, and two 89-foot harbor fireboats. The department has 9 paramedic units, and 10 of the engine companies are Paramedic Assessment Units. There is also a dedicated Urban Search and Rescue Unit and team. In 2003, there were 56,919 total calls for service including 37,602 medical, 9,795 lifeguard/marine safety, and 5,434 fire.

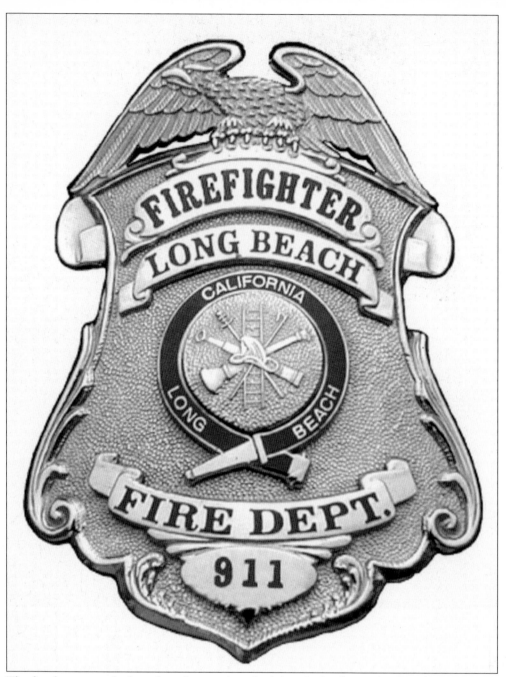

The fire department badge, whose history dates back hundreds of years, has long been a symbol of a great profession. The badge now represents a commitment to all of the people the Long Beach Fire Department serves and to our fellow firefighters who carry out their duties in a skillful, professional manner and are willing to sometimes risk the ultimate—their lives. Seen here is latest version of the Long Beach Fire Department Badge.